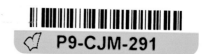
Water-Based Screenprinting Today

Water-Based Screenprinting Today

From Hands-On Techniques to Digital Technology

Roni Henning

Watson-Guptill Publications/New York

First published in 2006 by Watson-Guptill Publications, a division of
VNU Business Media, Inc., 770 Broadway, New York, NY 10003
www.wgpub.com

Library of Congress Cataloging-in-Publication Data

Henning, Roni,
 Water-based screenprinting today : from hands-on
techniques to digital technology / Roni Henning.
 p. cm.
 Includes bibliographical references and index.
 ISBN-13: 978-0-8230-5728-3 (alk. paper)
 ISBN-10: 0-8230-5728-3 (alk. paper)
1. Serigraphy--Technique. I. Title.
 NE2236.H462 2006
 764'.8--dc22

 2006006993

Senior Acquisitions Editor: Candace Raney
Editor: Amanda Metcalf
Designer: Pooja Bakri
Production Manager: Joseph Illidge

Manufactured in Malaysia

First printing 2006

1 2 3 4 5 6 7 8 9 / 12 11 10 09 08 07 06

HALF TITLE PAGE
Moth, Roni Henning, 22" x 30"
TITLE PAGE
Untitled, Regina Corritore

Dedication

To my wonderful husband, John Henning, who is never far from my thoughts. He was filled with the joy and wonder of life, which he passed on to anyone who ever met him. I'll never stop loving or missing him.

Acknowledgments

My first words of thanks go to my daughters Dawn and Diane Henning and my granddaughter Amanda for their contributions to this book and their loving support throughout the process of its creation. Special thanks goes to Richard Hellman for his tireless efforts in working out the chapter on computers. Theresa Mancuso went beyond the call of duty in transcribing my notes. Thanks again, Tree.

I also thank Marjorie Goldstene. All the prints were beautifully photographed by Kevin Ryan, with the exception of the slides that I received directly from the artists. Kevin also shot the instructional steps. Christina Lessa also contributed fine instructional photos. Theresa Mancuso took the photo of me on the back cover.

I want to thank the Lower East Side Printshop for contributing slides of many works they had printed. Thank you, Dusica and Jamie. Dennis O'Neil of Hand Print Workshop International generously provided me with art from his collection and with related information.

My sincere appreciation to James DeWoody for making all of those great monotypes. Thanks to all of the artists who contributed prints, especially Elsie Manville, Darra Keeton, Lynne Oddo, and Gina Corritore. I am very grateful to Candace Raney, senior acquisitions editor at Watson-Guptill Publications.

Finally, I want to acknowledge editor Amanda Metcalf, designer Pooja Bakri, and production manager Joseph Illidge.

Swimming the Santa Fe Nile, Lynwood Kreneck, 18½" x 13"

Contents

Introduction

When I wrote *Screenprinting: Water-Based Techniques* more than ten years ago, my goal was to convince other artists and printers that quality, water-based alternatives to traditional oil-based inks were out there. I had started to use them in the mid-1980s, thus turning my print studio into a safer, more environmentally conscious workshop.

Before I made the switch, I was always being told that I was putting my health in jeopardy because of the toxic fumes that evaporate from printed oil-based inks. Solvents, such as naptha and xylene, which I used to clean the ink out of the screens, didn't help either. Sometimes I had six hundred prints drying at the same time. In fact, during one commute home from a commercial print shop job in New York City, two fellow subway riders discussed their notion that the train must have been painted recently. I realized, though, that it was I who was giving off the smell.

My position as the Master Printer at the New York Institute of Technology's Screenprint Workshop, which printed limited editions of artists' works and functioned as a teaching facility, made me aware of the hazardous nature of the printing materials (solvents and oil-based inks) to which artists and students were subjected. Having completed a six hundred-piece, forty-color edition, the fumes permeated the walls of the print shop and anything organic, including me. That pushed me to change.

Despite the necessity of the change, the transition to a water-based system was not easy. At the time, I was making prints for well-known artists and publishers whose only concerns were professional quality. The results, not the process, mattered to them.

Plus, printers themselves make a stubborn bunch. Once they find a successful system, they resist change. Even I always had thought of water-based inks as a poor substitute to oil-based inks. I thought water-based inks only buckled the paper, throwing off the registration, and yielded inferior color quality. Still, armed with my statistics on the cancer-causing agents in oil-based inks, I set out to research what was out there.

TW Graphics in California is a screenprinting manufacturer of both oil- and water-based inks. More stringent environmental laws in California had created interest there in developing a quality alternative ink. The company's water-based inks resembled my previous oil-based inks' opacity. So I spent more than a year working out the problems and differences between the two and altering my own way of thinking to accept a slightly different methodology. I became hooked. The freedom to breathe without a mask was reward enough. Once I switched, though, I had to convince the artists and publishers to continue to print with me. The quality of the results was able to speak for itself, and it turns out, it spoke well.

At the Screenprint Workshop and later at my own studio, Henning Screenprint Workshop, I continued my research, aiming to make sure my printing process yielded consistent results, as I was printing large editions. Other artists, small print shops, and schools were beginning to see the need for change as well. Lynwood Kreneck, for example, developed Lyntex for Createx inks. I think of them as the pioneers in the push toward a better, safer printing environment.

Most schools have converted their screenprinting facilities to water-based systems, but commercial print shops have not. I hoped more large manufacturers would have developed a wider range of water-based inks in the past ten years, as has happened in the United Kingdom. However, a representative from The Union Ink Co. said the company discontinued its water-based Echo ink because manufacturing it costs more and because commercial screenprinters use an ultra-violet system to comply with environmental laws instead.

Still, to meet the demand from schools and small fine art printmakers, alternative companies have surfaced. For example, Standard Screen Supplies, a forty-year-old company, introduced a line of water-based inks five years ago. It has developed better inks and improved other screenprinting supplies. If printers keep up the demand, the more manufacturers will be forced to address the needs of artists and the educational community.

Since I published my first book, most artists have realized that there is no reason to risk damaging their health and the environment to make quality prints. I wrote and illustrated this book to expand on the techniques available for water-based inks and features wonderful prints from other artists and printmakers who have made the switch, displaying the diversity and creativity these new inks can achieve.

On occasion, I included prints made with oil-based inks as examples of particular color separations in this book , but the process for making them is the same. Chapter 1 also includes oil-based editions. Unless specifically identified as such, any print you see in this book is made with water-based inks.

Arboreal Boy, Igor Makarevich

A photo was taken of the artist's son. To make the photo look old, the negatives were scratched before exposing them to the screen. The image was printed with emulsified soft wax and pigment buffed to a shine, then tinted with dry metallic pigments. It was printed at Hand Print Workshop International.

New Directions in Water-Based Technology

On the first day of each of my screenprinting classes at the Lower East Side Printshop in New York City, I ask my students why they want to learn to screenprint when all one has to do to make a print is click a mouse. The students usually laugh and suggest a number of reasons why they want to learn the art form's traditional methods:

- Printing is more than reproduction.
- The artist and printmaker collaborate to create prints through trial and error.
- You learn about color's subtle nuances by mixing inks by hand and proofing colors.
- There is magic to pulling a squeegee and watching the color and shape appear on the paper. You can even incorporate the imperfections of the process into the art.
- The tactile quality of ink printed in layers produces a dimensional surface.
- It's about the process as well as the result.

There also is magic in a computer-generated image, but the computer is just another tool for artists, like the camera, that complements the process. Screenprinters are using computers to create the photographic color separations they previously had made with a copy camera and Kodalith film. Commercial print shops rely heavily on the computer, and universities and small fine art ateliers also embrace this technology, but only to enhance the traditional techniques of handprinting.

Revival of Tradition

My students at the Lower East Side Printshop are a unique group. Unlike my college students, class credits are not their motivation. Most of them have day jobs and are familiar with computers. Many even work in computer graphics, but they want to learn a process that incorporates technology into technique. So, in addition to the computer, traditional, hands-on involvement is reviving itself into its own "new direction."

Monotype printing, using a printing process to create an original or small series of related images, satisfies that need. Many screenprinters, always looking for new ways to be creative, combine monotype printing with etching and digital images.

A New Dimension

Dennis O'Neil, creative director of Hand Print Workshop International, has pushed the medium in still another direction. He uses powders, waxes, resists and adhesives to achieve a painterly effect. In *Moscow*, he printed a photo negative several times until a tactile surface, or relief print, rises. Then he pulls pigmented wax over the surface with a spatula, filling the relief area like an etching. These unique prints blur the area between print and painting.

Schools and universities are leading these printing innovations. Independent studios, like the Lower East Side Printshop in New York City, always have opened their doors to an active and vital artistic community. The Lower East Side Printshop, a not-for-profit print shop that is funded by

grants, foundations, and endowments, works with emerging and established artists from all over the world. Their key holder residency programs select artists to complete an independent project. Master Printer Jamie Miller and Executive Director Dusica Kirjakovic collaborate with the residents to make the editions. The shop provides space and equipment to artists who have no studio space and encourages artists who otherwise would not have been able to pursue printmaking.

The not-for-profit Fabric Workshop in Philadelphia, established in 1977, has expanded from fabric printing to helping artists combine techniques and develop new and original projects. The workshop makes water-based inks on the premises.

As current students graduate, The new developments in academic settings—computer technology, monotypes, hands-on techniques, innovative materials, and cleaner work environments—will enter the commercial print industry.

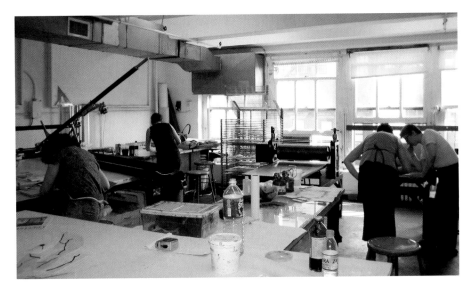

The Lower East Side Printshop

This not-for-profit print shop provides facilities and equipment, and thus opportunities, for print makers who otherwise would not be able to pursue printing.

Moscow, Dennis O'Neil, 10" x 12"

The photographic negative is printed several times in a pale transparent color to create a relief. Pigmented wax is applied with a spatula and pulled across the image without the screen to create a positive by catching in the relief areas. Printed at Hand Print Workshop International by the artist.

Cries and Pain, Juan Sanchez, 27½" x 53"

Digital photos were used for this combination screenprint, monoprint, collage, and chine collé. Fabriano Rosapina paper was torn in oval shapes and chine colléd. The artist made the monoprint drawing, printed two more photos, and tore and collaged them. The heart and text were screenprinted. The print is provided courtesy of Juan Sanchez, the Lower East Side Printshop and Dieu Donne Papermill. It was printed at the Lower East Side Printshop by Dusica Kirjakovic, Courtney Healey, and Marc Lepson, in collaboration with Juan Sanchez.

I

Artist and Printer Collaborations

Artists have always relied on master printers to help create their prints. All good ateliers have a master printer to facilitate the production of prints. Artists do not need to understand how printing tools and equipment work, but need to understand both their possibilities and limitations. Artists and publishers seek out print shops based on the reputations of their master printers like Dan Welden of Hampton Editions, Kathy Carrachio of K. Carrachio's Printing Studio, and Dennis O'Neil of Handprint Workshop International.

But something besides skill sets good master printers apart: They create safe and inviting atmospheres for the artist to work in. They understand the artist's needs and guide him or her in the right direction, maybe even in a direction the artist didn't think possible. A sense of discovery occurs between the artist and printer. Good master printers follow their intuition when working with artists. Each artist arrives at a print shop with his or her own unique style and imagery, and his or her sole purpose is the creation of a print. I once heard screenprinting described as giving birth, with the master printer playing the part of midwife.

Some shops devote all their time and facilities to one artist, personal attention that a well-known artist can expect. A publisher working with a print shop commissions a print from a particular painting, and a publisher's payout determines the number of colors used per print. The master printer then analyzes the piece with the artist to create a print that maintains the feel and character of the original within those limitations.

Hugh Kepets's Exacting Approach

Working with Hugh Kepets, as I have on a number of prints, was always an adventure for me, and for him. One of my favorite and most prepared artists, he was familiar with screenprinting and had worked with other printers. Kepets arrived at the studio with an exact schematic from which he would then make all the color separations using black markers on frosted Lexan textured acetates. The marks were not always opaque enough to expose onto a screen, so I had to improvise on my screen wash-out technique, often underexposing the screens and washing them out carefully with a spray water bottle. His drawing skills and attention to detail always impressed me, and he always credited me with understanding the colors he wanted and how to achieve them. This is where the collaboration really began.

We would begin by discussing what would happen when certain colors were mixed and how the results would affect the print, which would be made of multiple transparent overlays. As we continued to experiment with color, the print eventually would take on a life of its own. Kepets always asked for my opinion and always took my advice. His interest in printmaking came from this love of problem solving.

Each artist with whom I worked presented a different set of problems, and I see the master printer as the problem solver. Before beginning any project, I sit down with the artist and talk about his or her art and expectations.

Union Square III, **Hugh Kepets, 3' x 2'**

Kepets drew the separations on Lexan textured acetate with black markers. I made the print at Henning Screenprint Workshop.

Matching Jack Youngerman's Colors

Jack Youngerman came to the print shop New York Institute of Technology's Screenprint Workshop with a maquette that he wanted to make into large, color field prints, and the color had to be just right. Youngerman used the same image for the first eight editions, changing only the color. We then made another image and another eight color versions. We had printed each color field from a handmade stencil that I delicately painted onto textured acetate using lithographer's opaque and brushy strokes to simulate modulated tonality. Most printers now use black acrylic paint or ink to paint stencils. Then John Henning hand-embossed them after printing.

Youngerman came to the studio to supervise the color proofing, wanting an exact color match of each of his paintings. Color is one of my specialties, so I enjoyed the opportunity to mix and match for him. Though I based the prints on an original, we were not trying to reproduce it. The prints had to keep the integrity and character of the art, but they served as interpretations.

Often an artist will invent an original print in the shop after he or she has become familiar with the medium and its possibilities. This could be very exciting, pushing the medium to its limits to see what new techniques would arise.

Wood Cut Screen

Youngerman made this wood cut that was then printed and copied onto Kodalith film and burned onto a screen.

Untitled, Jack Youngerman

The separations for these prints were painted with lithographer's opaque on acetate to simulate the modulation of tone in the original painting. Youngerman and I mixed the colors. Regina Corritore and I, with the assistance of Chris Corritore, printed the two images below with oil-based inks at New York Institute of Technology's Screenprint Workshop. Then John Henning hand-embossed each print

Maintaining the Feel of Elsie Manville's Originals

People everywhere love and collect Elsie Manville's paintings, which she shows at Krashauer Gallery in New York. Her publisher ordered a print edition of one of her paintings, but Manville wanted only to follow it closely, not reproduce it exactly.

After analyzing the painting, which she had painted in a realistic style, I decided to handdraw stencils to maintain the integrity of the original without ignoring the special look of a screenprint. I told her that using black China markers on textured acetate, when layered and printed using transparent colors, would simulate the continuous tone of the painting.

Manville drew the key plate to ensure that it had her touch, and I created the other stencils. We collaborated on the separations: I would make a screen and print the color, then draw the next separation based on the developing print. Eventually, we didn't use the original at all. Instead, Manville guided the direction of the print.

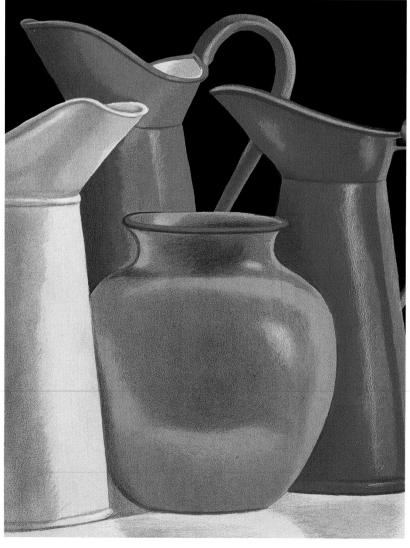

Original Painting

This oil on paper painting was the basis for the print at right.

***Conversations,* Elsie Manville**

This print was created with Rubylith film stencils and handdrawn color separations on textured acetate. Manville worked closely with me to change the colors from the original. It was printed in twenty colors at Henning Screenprint Workshop.

James DeWoody Embraces Unpredictability

The difference between improvisation and unpredictability depends on the goal of the artist. When you improvise, you make impromptu decisions at each stage. Unpredictability has less to do with the artist and is the result of the medium's ability to control part of the outcome by the way it prints. James DeWoody seeks unpredictability when he makes monotypes. He relies on the inconsistent nature of gouache, watercolors, and pencil. He makes art on autopilot, and he likes distractions, whether a radio, other artists, or lots of conversation.

Many other artists prefer quiet and to be the only one making a print at the time. DeWoody, though, said, "I just like the art to come out of my hands without being self conscious. You must ride the technique to the degree that you can. No matter how resolved the painting or drawing is, the result is never what you expect. That's the magic of it."

Total control is not possible because the marks that come off the screen depend on the thickness or thinness of the painting on the screen and what the screen wants to release.

My job as the master printer is to use my skills to coax the screen to release as much of the painted image as possible. I make suggestions to each artist and demonstrate techniques that would be useful based on my knowledge of each artist's work and my experience with the screen. Working with DeWoody, who tries anything to deliberately push the unpredictable nature of the monotype process, always educates me.

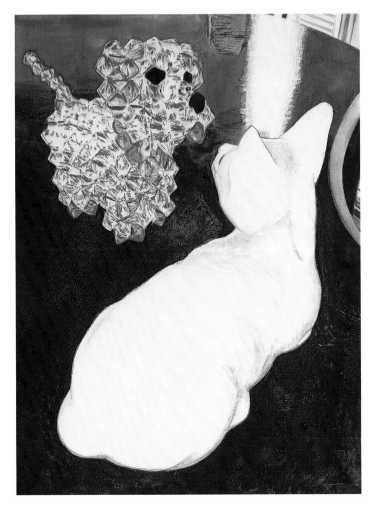

Sparky and Wax Cat, James DeWoody, 30" x 22"

This monotype was based on a photograph. DeWoody drew and painted it with gouache and watercolors, and it was printed at Henning Screenprint Workshop.

Creating a New Original with Romare Bearden

Romare Bearden, one of America's great artists, showed me what improvisation is all about. When I received his collage from his publisher, I thought it would be a straightforward job. I had not spoken to Bearden directly though I prefer the artist's involvement. With no information other then size with which to work, I decided to follow the original: a collage that consisted of only black-and-white, mostly white, photographs and magazine images, closely by making photographic stencils.

When I finished the proof, satisfied that it looked like the original, I traveled to his studio in Long Island City, N.Y. (he didn't have a phone or cell phone). Fortunately, for me, he was usually there working. Artists' studios vary from neat to messy and noisy to quiet. Bearden's was quiet and austere. He worked on one table with a chair in the almost empty room. He had turned all of his paintings toward the wall to avoid distractions. Underneath the table sat a radio and a box filled with magazines and pictures for use in his collages. It was summer, and the studio had no air conditioning, though a single window provided some air.

Bearden greeted me at the door with a smile. The quiet, unassuming man focused completely on his work. He looked at the proof immediately, sat down at his one table, and with complete confidence and no hesitation started making changes. As much as I had tried to emulate the original, I soon discovered he was creating a totally different piece.

Each time I visited his studio, he quietly reviewed the new proof, then drew all over it and instructed me on the new color changes. The piece went from a white photo collage to a graphic gray, red, and blue print. He even changed the figures.

At each stage, he seemed to know exactly what he was aiming for, but every time I returned, he changed it again. On the fourth and last proof, he drew his final changes. He even added the mop from the original back in. The final proof that satisfied him no longer resembled the original collage.

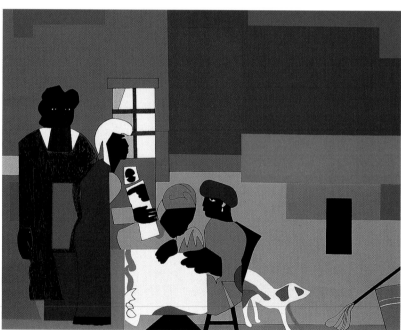

Blue Carolina Morning, Romare Bearden, 18" x 22"

This final proof for the screenprint of *Blue Carolina Morning* (above) shows Bearden's drawing and corrections for the finished print. I created the print (below) at New York Institute of Technology's Screenprint Workshop with oil-based inks and handcut Rubylith film, painted acetate separations. Proof © Romare Bearden Foundation/Licensed by VAGA, New York, NY. Blue Carolina Morning © Romare Bearden Foundation/Licensed by VAGA, New York, NY.

Collaborations

A master printer's knowledge grows with every artist with whom he or she works. Only years of experience help one understand not only what tools to use and how to make a stencil and print a color but also how to solve problems. Every print edition has them; it is the nature of the beast, and the solutions separate the good printers from the mediocre. Anyone can set up a shop and call him- or herself a master printer.

Some printers hate the title master printer, finding it old-fashioned. Others feel the title requires at least ten years of experience. But the proof is in the pudding, as they say, and truly earning and deserving a reputation takes a long time.

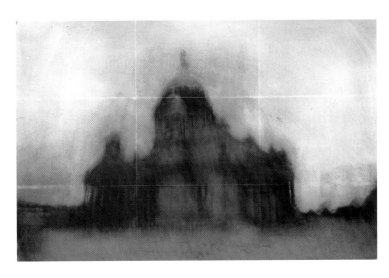

Cathedral, **Andre Chezhen**

For this wax and pigment screenprint on Arches paper, the positive and negative images were printed with transparent base. The negative was developed as a relief surface to hold pigmented wax and the positive was dusted with dry pigments while still wet. Dennis O'Neil created this print in collaboration with Chezhen and printed it at Hand Print Workshop International.

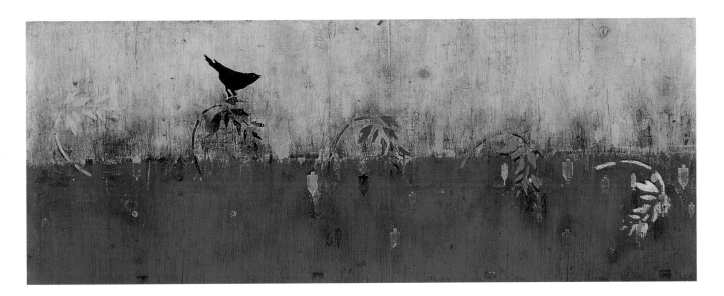

Nightingale II, **Pavel Makov, 19" x 52"**
This excavated screenprint was printed many times to create a dimensional surface. It was then saved, scraped, and washed. Dennis O'Neil guided Makov as he repeated the process, creating a rich surface on which ink and image molded into one. It was printed at the Hand Print Workshop International.

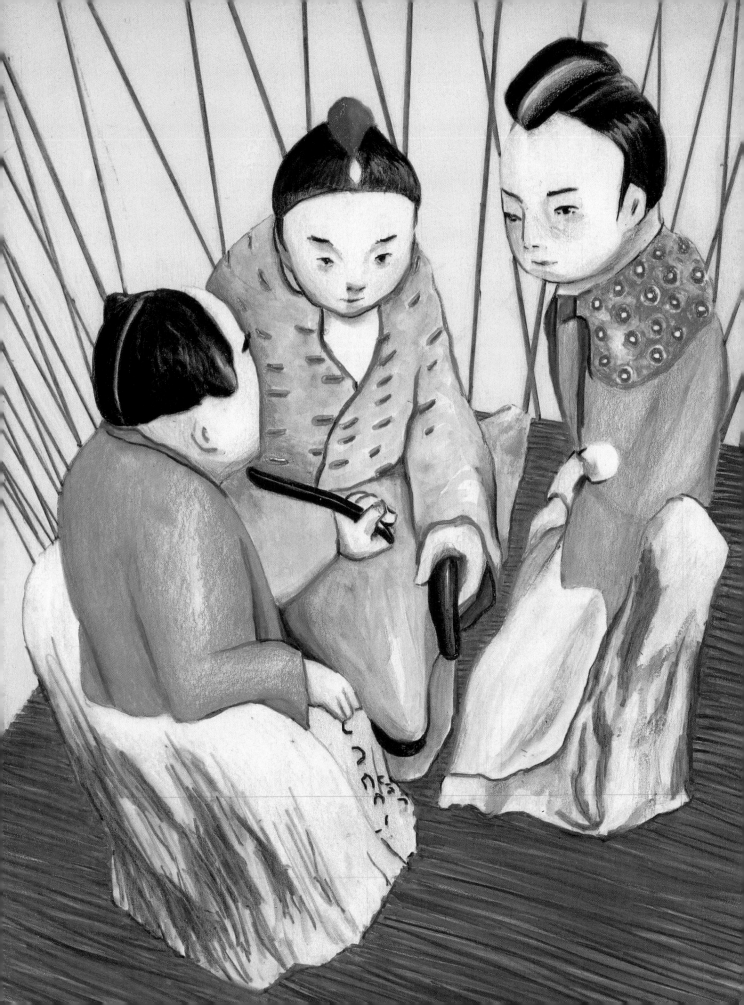

2

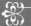 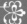

Monotypes and Monoprints

A monotype or monoprint is simply a painting made using the printing process. The distinction between the two is determined by how the artist begins. To make a monotype, start with a blank opening on the screen. To make a monoprint, start with a pre-existing image, a stencil. Both methods have always been loved by artists and, and both force them to expand their concepts and push them in directions they would not otherwise have explored.

Traditionally, artists made them with etching or litho presses, but water-soluble screenprinting inks allow them to be made through a screen differently. You do not need to reverse an image as with a press or use expensive printing equipment. Just as improved methods and innovative techniques have blurred the boundaries between screenprinting, etching, and litho, the technical distinction between monoprints and monotypes has become irrelevant. What remains relevant though is the final product, the art.

Begin the process with a screen. You can purchase pre-stretched screens or make them following the instructions on the following pages.

Then We Have No Choice, James DeWoody, 30" x 22"

This screened monotype was made using watercolors, gouache, and crayons and printed over a prepared drawing. I printed it at Henning Screenprint Workshop.

Spontaneity Creates Variety

Darra Keeton found the monotype process more than ten years ago and loved the exciting and surprising results immediately.

"Every medium has its particular restrictions as well as its freedoms, and I like to shift from one image to another," she said. "For me, the beauty of screened water-based monotypes is the possibility of having fluid or precise marks as in watercolor, where you can work either carefully and slowly or quickly and spontaneously. It differs from straight painting in the fact that you can keep an image through the ghost prints and develop it in several pieces. The most fun comes in working directly on the screen, making rapid decisions before the transparent base dries. I love that I can work directly, without the image being reversed as it is on an etching press."

Keeton works on five or six prints at a time, painting and printing her images onto two or three sheets of paper, then changing the image and printing it over the others, so she finishes with several final but different prints.

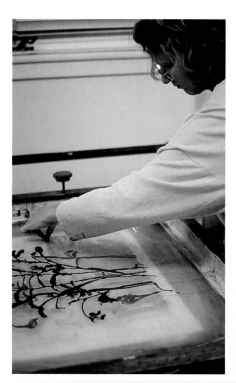 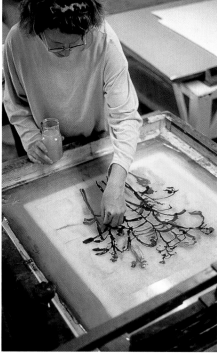 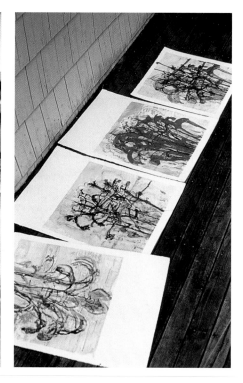

Working Spontaneously

Darra Keeton likes to improvise, painting directly onto a wet screen, then printing and quickly repainting without washing the image out of the screen.

Creating a Series

One printing project yields more than one print for Keeton, producing many original works of art.

Improvising

Flow with the process, and experiment with paint, pencils, and other materials. Make it up as you go along, letting each stage of the print influence the direction of the next.

Start the monotype process without a set of directions or a matrix. The way each set of marks have translated from the screen to the paper will suggest what to paint next. Just as an actor or actress would derive cues from the preceding lines during an improvisational performance, an improvising printer gets his or her direction from the way the print is evolving.

Darra Keeton makes prints in just this manner. She paints and print on several papers, switches images, prints over the preceding ones, and, based on the results, repaints the screen for the next stage.

Untitled, Darra Keeton

Keeton painted the screen with watercolors, gouache, and water-soluble crayons, and I printed it at Henning Screenprint Workshop.

Matrix Delivers More Precise Results

Artists approach monotypes differently; they can draw or paint directly onto the screen as they would onto paper or canvas. Many artists, though, rely on a matrix. A matrix gives an artist something from which to work. The artist can follow this photo, drawing or painting, however loosely, using it as a map or outline.

James DeWoody's latest series of monotypes involve ceramic figures arranged in group settings as if they are conversing. Once the arrangement satisfies him, he takes several digital photos and prints them. Then he makes a color photocopy, his matrix, at the size he has planned for the monotype. He can see the photo through the screen and refers to it as he paints his image.

Though his process is specific, the screen's tendency to resist or release parts of the painted image still make the results unpredictable.

Lately, he has used different media to resist each other. For example, he prepared a sheet of paper with wax crayons and acrylic polymer. The dimensional acrylic caused the base and paint to pull back as the printing process squeezed them through the screen.

"No matter how resolved the painting or drawing is, the result is never what you expect," said DeWoody. "That's the magic of it."

Prepared Drawing

DeWoody drew on prepared paper and will print over this drawing.

Follow the Drawing

He paints the image onto a screen with watercolors, using an enlarged photograph, placed between a light box and the screen, as a guide.

It Sounded Like Thunder, James DeWoody

DeWoody painted the screen with watercolors, gouache, and chalk and printed it on a paper prepared with wax crayons and acrylic polymer.

Start with a Screen

Make a screen by stretching fabric tightly over a wooden or metal frame and adhering it with glue or staples. Wood remains the material of choice for its lower cost and versatility; you can use wooden frames to print anything from T-shirts to fine art editions. Make sure whatever frame you use is strong enough to withstand the tension of the fabric mesh without warping as you stretch it.

Wood Frames

Pine and cedar are light, and cedar is water resistant; an advantage considering you will wash the screen many times, especially when applying and removing stencils. You can handstretch wood screens or machine-stretch them as you would metal frames. Machine-stretching uses clamps to pull and hold the fabric over the frame.

Place the clamps side by side on each side of the screen. Attach the fabric to each clamp and tighten the clamps. Turn the compressor on to pull the clamps and the fabric away from the frame. Apply the frame adhesive and allow it to dry, then remove the clamps.

Build the frame based on the size of the image you want to print, allowing at least four inches between each side of the image and the respective side of the frame. For example, if you are printing a 16- x 20-inch image, the inside of the frame should measure 24- x 28-inch. A screen this size requires 2- x 3-inch pieces of wood, and a larger screen, say 60- x 80-inch, would need 2- x 4-inch pieces of wood. Join the wood at the corners with a butt, mitered, end-lap, or tongue-and-groove joint.

Building a Butt Joint

Have the wood cut to size when you buy it, or cut it yourself. Place the sides together to make a corner. Put epoxy on the end of one piece of wood and attach it to the second piece using two or three nails or screws long enough that half the length goes into the second piece of

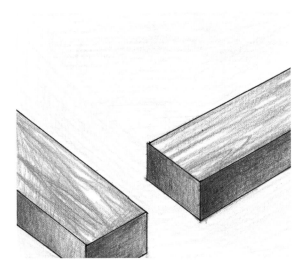

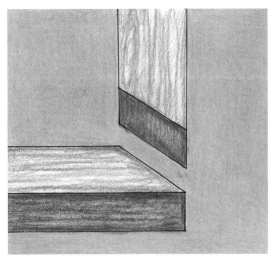

Butt Joint

Two pieces meet at right angles.

Mitered Joint

The two ends are trimmed to meet at a 45-degree angle.

wood. Make sure you maintain a right angle. To use screws, drill part of the way into the wood, then add the screw and finish with a screwdriver.

Building a Mitered Joint

Saw the ends of the wood at perfect 45-degree angles using a miter box, or have the ends pre-cut when you buy the wood. Glue the ends and secure them with corrugated nails.

Building End-Lap and Tongue-and-Groove Joints

End-lap joints overlap each other. Tongue-and-groove joints, the most stable, fit into each other.

Metal Frames

Aluminum and steel frames are very stable and do not warp. No screen should warp, but you should use metal frames when you need to stretch a screen to the greatest possible tension. A tight stretch prevents distortions when applying stencils. Not only does a loose screen affect the stencil's image, it does not release from the paper well when printing, causing watermarks and rainbow shapes in the printed ink.

Steel frames are durable but their weight makes large ones difficult to handle. Aluminum frames are lightweight and have strong, welded corners. The tops of metal frames are sandblasted or ground so the fabric will adhere well. Some commercial print shops use metal frames for precision printing on electronic parts and printed circuits.

There is a metal frame that has four locking bars that hold the fabric in place within grooves, without glue. You can then remove the fabric and replace it with new fabric; an advantage when monoprinting, which stains screens quickly. Metal frames can scratch light tables when you are exposing an emulsion-coated screen, so be careful when placing one on glass.

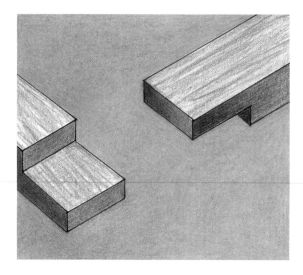

End-Lap Joint

Two lips overlap.

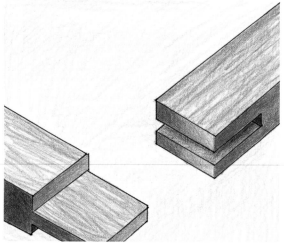

Tongue-and-Groove Joint

Negative and positive ends interlock.

Choosing Fabric and Stretching a Screen

Traditionally, printers stretched silk over frames, hence the term "silkscreening." However, silk loses tautness when used frequently, and the bleach that printers use to reclaim photo stencils for re-use destroys the silk. Nylon works well, but monofilament or multifilament polyester is strong and stable when stretched. Printers print most fine art editions with monofilament screens. Multifilament uses many strands wound together and is more common in the textile industry. Monofilament, which uses single strands, is easier to clean, especially when using water-based inks. Look for these fabrics at screen supply companies and art supply stores.

The number of threads per inch determines the size of the mesh. The more threads, the finer the mesh, and the fewer the threads, the coarser the mesh. The space between the threads is the mesh opening. Use finer mesh to print detail and halftones that require thin deposits of ink. Use coarse mesh to print flatter, open shapes that require heavier ink deposits. Manufacturers would label coarse monofilament polyester mesh as under 180-mesh and a finer mesh between 230- and 300-mesh.

Water-based inks print best with 200- to 260-mesh monofilament. Monofilament comes in white, yellow, and orange. The last two are designed for use with indirect photo stencils, as the color prevents light from bouncing when you expose the stencil to an ultraviolet light. Bounced or scattered light can cause an uneven exposure. Use white mesh for stencils drawn directly on the screen and for monoprinting.

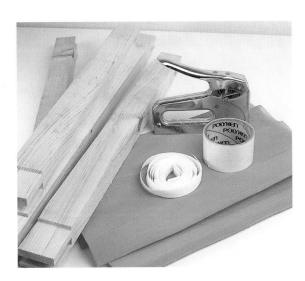

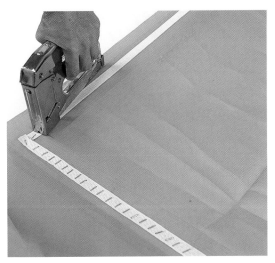

Gather Supplies

Gather four pieces of wood cut according to one of the four kinds of joints on pages 25 and 26, a piece of orange polyester monofilament trimmed to about eight inches longer and eight inches wider than the frame, a staple gun, staples, fabric tape, a small block of wood, a mat knife, and wide plastic screenprinting tape or duct tape.

Staple the First Two Sides

Assemble the frame and lay the fabric over it so the fabric overlaps each side of the frame by four inches. Apply fabric tape over the fabric along the first side of the frame. Staple the two corners and then that side of the frame. Then apply fabric tape to the adjacent side and staple the corners where the tape overlaps. Pull the fabric and tape tightly to the third corner and staple the third corner and then the second side.

Stretching the Screen

After building a frame using one of the joints on pages 25 and 26, cut your fabric to measure four inches larger than the frame on each side, and lay it over the frame. Lay a piece of fabric tape over one side of the mesh to keep it from tearing, and staple the tape and mesh on one corner. Pull the fabric tightly along the wood to the next corner and staple the next corner. Then fill the first side with staples. Repeat on the next side, making sure to pull the fabric tightly to the next corner so you have a vertical and horizontal side stapled.

Using a block of wood in your nondominant hand for leverage, pull the fabric across the frame away from the third side (opposite the first one you stapled) as tightly as you can. Lay a strip of fabric tape over the mesh and third side of the frame, then staple this side. Move the block of wood with the stapler to maintain optimum tension. Repeat this procedure on the last side.

Trim the excess fabric with a mat knife or razor blade. Place wide, plastic tape, such as duct tape, over the staples and fabric. Run duct tape so it overlaps the inside of the screen and the wood evenly to prevent ink from seeping into the groove between the wood and mesh. Many printers shellac or varnish the wood to protect it, though I find the duct tape sufficient. Your screen should have no hills and valleys as you run your hand over it.

Degrease the fabric using an abrasive, powered cleanser, such as Ajax or Comet, to help photo emulsion adhere. Screen supply shops also sell degreasers. Water will sheet over a degreased screen without being repelled when you wash it with a hose.

You can purchase ready-made screens from screenprinting suppliers (*see Resources on page 141*). Larger ones can get expensive.

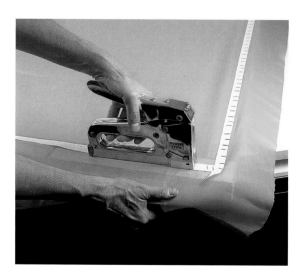

Staple the Third Side

Pull the fabric taut over the third side of the frame, placing a small block of wood between the overlapped fabric and the frame for leverage so you can pull the fabric outward, not downward. While holding the fabric tight, apply fabric tape along the third side of the frame. Staple the third side of the frame, moving the block of wood along the side of the frame to help you pull the fabric tighter.

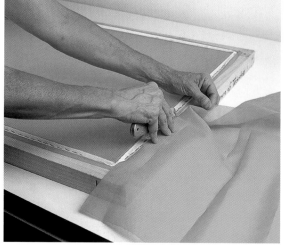

Staple the Fourth Side

Again using the block of wood for leverage, apply fabric tape to the fourth side and staple it to the frame. Trim the excess fabric with a mat knife. The finished screen should be tighter than canvas, with no give. Place wide plastic or duct tape over the staples and overlapping the wood and screen on the opposite side to prevent ink from seeping under during printing.

Preparing a Monotype Screen

Start with a screen of white, 195-230-mesh fabric. Block out the areas you do not want to print. To create a monotype, you block out these areas using any material that will adhere well to the screen, such as packing tape, shelf paper, screen filler, or photographic emulsion.

Using Tape

Draw directly onto the inside of the screen (the side that faces you) with a pencil and ruler. Then apply wide, transparent packing tape outside the lines to create the opening. This thin, tacky tape adheres securely and does not interfere with the pull of the squeegee. Its transparency lets me see the paper onto which I am printing, helping me register the printed image and screen.

Cover the rest of the exposed screen, to the edges, using clear contact (shelf) paper, leaving only the area to be printed open. Again, clear contact paper allows me to see through it, and contact paper adheres well, so it will not interfere with the squeegee.

After several printings, the tape does break down, so this method will not work for complicated, many-tiered prints. It does work well for artists who frequently change the size of the opening to accommodate different size prints because it is fast and immediate and does not require a photographic stencil stripper, as do the following techniques, which use photographic emulsion to block out the screen.

Monoprint vs. Monotype

The exposed parts of the screen, shown here in white, will print when you flood ink over them. When creating a print, you will cover the negative spaces of the image on the screen so the rest will become your print's positive image. If you place a stencil on the screen and also paint or otherwise cover other parts of the screen, you are creating a monoprint. If you work directly on the screen without another pre-existing image, you are creating a monotype.

Making an Opening with Tape

Draw the opening on the inside of the screen using a pencil and ruler. Place clear packing tape outside the lines on the inside of the screen. Cover the rest of the mesh outside the opening with clear contact paper.

Using Tape and Photo Emulsion

Again draw a square or rectangle on the screen. This time, line the inside of two opposite lines with Scotch Magic tape and press it down firmly, as any bubbling will allow the emulsion to seep under and produce a ragged edge. Pull a small amount of emulsion across the outside edge of the tape with a small, sharp piece of illustration board, using firm pressure and keeping the board slanted to push the emulsion into the screen. Do not overlap the inside of the tape so the emulsion does not cover any part of the opening. If this does happen, though, simply remove it with water.

Dry the emulsion with a hair dryer and remove the tape along the inside on the opening. Repeat the process on the remaining sides. Working on opposite sides ensures perfect corners Fill in the remaining exposed mesh outside the intended opening with emulsion. Dry the emulsion thoroughly, for at least sixty minutes and then expose it to light or sunlight for another five minutes to harden it more.

Using Photo Emulsion and Rubylith Film

Coat the screen with photo emulsion and cut a Rubylith film square to expose onto the screen. When you expose the screen, the emulsion that was covered by the film will wash away so you can print through it. This is covered in Chapter 4.

Draw the Opening

Draw a square on the screen with a pencil and apply transparent tape along the insides of two opposite lines.

Apply the Emulsion

Pull photo emulsion along the tape using a sharp piece of illustration board.

Remove the Tape

Dry the emulsion with a hair dryer, then remove the tape carefully to reveal sharp, clean lines. Repeat on the other two edges.

Painting a Monotype Screen With Watercolor and Gouache

Raise a white 195- to 230-monofilament mesh screen an inch or two off the table to prevent the paint from touching the table as you paint. Paint on the inside of the screen to achieve a direct, not reversed image. Watercolors will release from the screen more easily than gouache, which is denser and tends to resist in the screen, a quality that gives the print its unpredictable nature. Whether you paint thick or thin applications also affects the resulting print. The paint can stay in the screen for more than a week before printing.

Experiment with various paints and techniques to develop a more informed idea of how to get the desired results. Painting layers yields unpredictable results; it could be the top color or the bottom, or the extra thick application could act as a resist so only the edges of the painted areas print. You may like these effects. Otherwise, print in multiple steps if you want to layer colors.

The pigment concentrations in different brands also produce varying results. The more pigment, the more resist, thus the more passes with a squeegee it takes to release the image from the screen. The cheaper the watercolor, the more likely it is to print on the first pass. Colors also differ by brand.

Dry the paint with a hair dryer before printing to prevent it from smearing. The transparent base will re-wet the paint when you print.

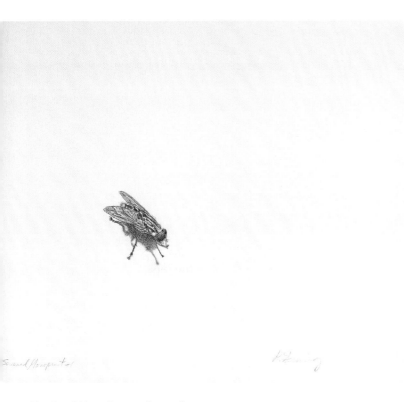

Fly, Roni Henning, 22" x 30"

I drew on the screen with graphite and printed with TW Graphics transparent base at Henning Screenprint Workshop.

Untitled, Dan Welden

Welden and I printed this watercolor and crayon screened monotype on Hahnemühle paper. Welden painted on a wet screen with the watercolor. It releases quickly.

Drawing a Monotype Screen

When I first started drawing directly on the screen, I used water-soluble pencils, knowing that the lines would drop and print perfectly, but graphite surprised me. It sticks in the mesh and does not dissolve in the printing base, so only the pressure of the squeegee forces it through the screen. Drawing on the mesh requires practice to feel fluid, but the printed results are unique, different from drawing with graphite on paper. Static electricity makes some of the graphite scatter in random patterns as it transfers to the paper, just enough to create an interesting effect near the image but not enough to interfere with it.

Chalk

The feasibility of printing graphite opened my eyes, so I experimented with dry, compressed chalk next. They draw beautifully on the screen, with a look similar to a pastel drawing. I created too heavy a deposit, though, and the chalk acted as a resist, releasing slowly after several printings. Some of the chalk might fall through the screen while you are drawing. If you want to use it for a dimensional effect, register the paper before drawing on the screen. If not, remove the paper before drawing or wipe the dust away before printing.

Charcoal

Use only soft charcoal sticks or charcoal pencils. Like graphite, charcoal sits on the mesh until the squeegee pushes it through. Like chalk, dust falls through the screen onto the paper.

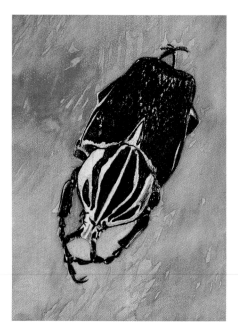

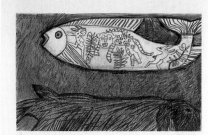

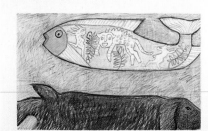

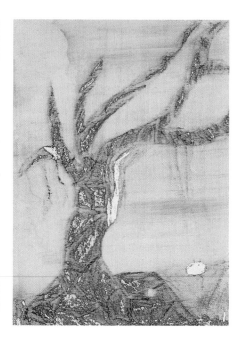

Beetle, Roni Henning

I painted with watercolor and dried it, then drew with charcoal so the drying process wouldn't disturb the charcoal.

Fish, Roni Henning

I drew this image onto 195-monofilament mesh with charcoal and printed it twice with TW Graphics transparent base at Henning Screenprint Workshop.

I Talk Jive, Amanda Henning

Henning painted this image on the screen with gouache, which resists in the screen so only the edges print.

Textural Rubbings on a Monotype Screen

You can draw on both sides of the screen with any of these mediums to, for instance, increase the darkness without increasing the density of the applications, a technique especially helpful with charcoal, which usually will drop during the first pass of the squeegee, leaving very little in the screen for a second printing.

If you choose to combine charcoal and watercolors in one pass, paint the watercolors first so you can dry them with a hair dryer, which would blow the charcoal out of the screen.

Water-Soluble Crayons and Pencils

When printmakers first started to experiment with screened monotypes, they used only water-soluble crayons and pencils, which draw on the screen easily and usually print rich, opaque color. The intensity of the color also remains through several printings. When used exclusively, though, I find the color too "sweet," like process color in magazines.

Combining watercolors, gouache, and water-soluble crayons allows you to create more complex and exciting colors with a complete palette, and the character of the line is unlike a typical drawing: A dense crayon application will act as a resist so only the edges print, which yields a unique and beautiful quality. Print several times on different sheets of paper to remove the line from the screen.

Water-soluble pencils, on the other hand, rarely resist in the screen. When I use them, I often draw on both sides of the screen, as with graphite, chalk, and charcoal, to get a better result.

People have made rubbings of tombstones and monuments for years by placing paper over the stone and running a pencil over it. The pencil records only the raised areas of the texture. To impress a rubbing on a screen for printing, place a textured object, such as a window screen, rope, lace, or wood under the flat side of the screen. Using graphite pencils, charcoal or water-soluble crayons, such as Caran D'Ache, draw on the inside of the screen, over the textured object or objects. Do not press too hard or you will create a resist in the screen, unless, of course, you want that effect.

Rubbing Example

I made the background of this monotype by rubbing a graphite pencil onto a silkscreen that was placed over a metal window screen, picking up the texture of the screen. I also drew on the silkscreen with colored pencil.

Untitled, Sue Daykin

Daykin used a combination of water-soluble materials to paint the image for this monotype on the screen. She printed it at her studio.

Printing Monotypes

You print monotypes and monoprints using transparent, water-based screenprinting base and thus can print onto any surface onto which you can screenprint, including craft paper, cardboard, wood, and rice paper. You can get transparent base from TW Graphics, Standard Screen Supply, Speedball, and Createx. The image you want to print should determine your surface choice. I usually print on 100 percent cotton rag paper, such as Arches Cover, Rives BFK, Somerset, or Stonehenge. Pencil and charcoal drawings print better on smoother, harder paper like Stonehenge, which retains most of the drawing's subtleties. A coarse, more absorbent paper would add its own texture to the overall image.

Handprint the screen by fastening the prepared screen into the hinge clamps on a table or board. Hold the front of the screen in an up position, meaning raised slightly above the printing surface, using a block of wood. Mix 10 to 15 percent retarder into the transparent base to keep it fluid and retard the drying time, which will help paint and crayons soften and dissolve out of the screen into the base. Two good retarders are Golden Acrylic and Propolyne Glycol. Align the paper under the screen and mark its position using registration cards—pieces of cardboard placed on each of two sides of the paper. Masking tape will work if you are printing just one or two prints. Tape the paper down if you are not using a vacuum table. Use a squeegee to flood the screen, pushing the transparent base away from you across the painted image. I usually pull the base back and forth across the image two or three times until I see the color start to dissolve and show on the squeegee's blade.

Remove the block of wood and lower the screen directly onto the paper. Keeping the squeegee at a 45-degree angle to the screen, pull the squeegee across the image using even pressure. Lift the screen and examine the print. If it looks too light and you want more color, reflood the screen with transparent base. If the base has picked up too much color, scrape the transparent base into a container and start over. Otherwise, you will print streaks of color on your image. Then reprint and examine the result. If desired, you can print a second, lighter print from the same screen. To do so, make sure you position the paper in exactly the same place under the screen. The image on page 35 was printed with a one-arm squeegee.

Pour Transparent Base

Julio Valdez painted this screen with watercolors. After preparing a screen as such, pour transparent base onto the screen while it is raised in preparation for flooding the screen.

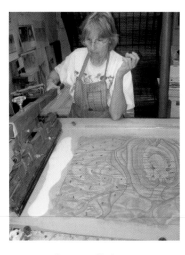

Get Ready to Pull the Base

Pour base along the entire side of the image so the one-arm squeegee can achieve smooth, even coverage.

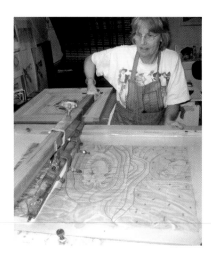

Rewet the Painted Image

Flood the screen with transparent base by pulling the squeegee across the screen.

The printing process adds its own dimension to the character of an image, different from a direct drawing or painting. The unpredictable way a screen withholds or releases painted materials adds a surprise element.

Also experiment with painting and drawing techniques. Try painting a thick, dry application of watercolors and compare the resulting print to one from a thin, wet application. Leave the base on the screen for varying amounts of time before printing, then compare the results after printing later. However, the base can stay flooded over the screen for no more than a couple minutes, or it will dry in the screen and cannot be reclaimed without using harsh chemicals. Try drawing with crayons onto a dry screen, dipping them in water, or drawing into an already flooded screen.

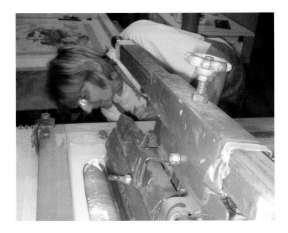 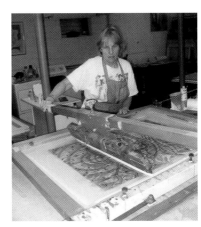

Let the Color Dissolve into the Base

Pull the squeegee over the image a few times until you see the color start to dissolve.

Print the Image

Lower the screen onto the paper and push the squeegee across the screen again to release the image onto the paper.

Reveal the Print

The transparent base will have picked up the watercolor and then transferred to the surface. When you raise the screen to examine the print, you will see that the color still is visible in the screen as a stain.

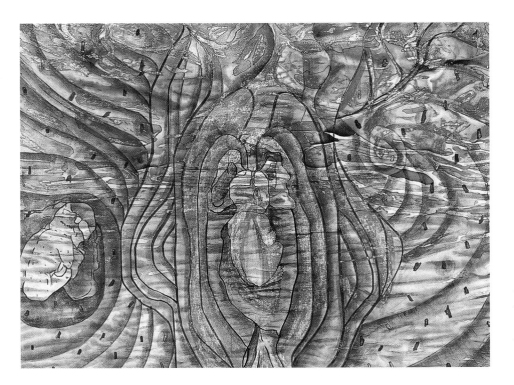

Vengo Naciendo III (I Am Being Born III), Julio Valdez

The artist painted and drew the image on the screen for this monotype using watercolor, gouache, and crayons. I then created the print at my studio.

Using Screenprinting Inks and Acrylic Paint

You can make monotypes using a wet-on-wet technique with printing inks. Add retarder to the ink to keep it from drying too quickly. Build the image from front to back with brushes or squeegee bottles to apply the ink, keeping the ink wet by working quickly enough so it does not dry. The first colors you apply will appear on the front of the image. Working quickly, fill all the exposed mesh of the screen. To print, pull the squeegee across the painted image, either with or without base. The last colors you applied will push the image onto the paper. The inks usually print opaque.

Another way is to use acrylic paint to tint the transparent base. When you flood a screen drawn with graphite, the base forces the drawing onto the paper, but the image remains locked in the colored base so you can print successive lighter versions if you desire.

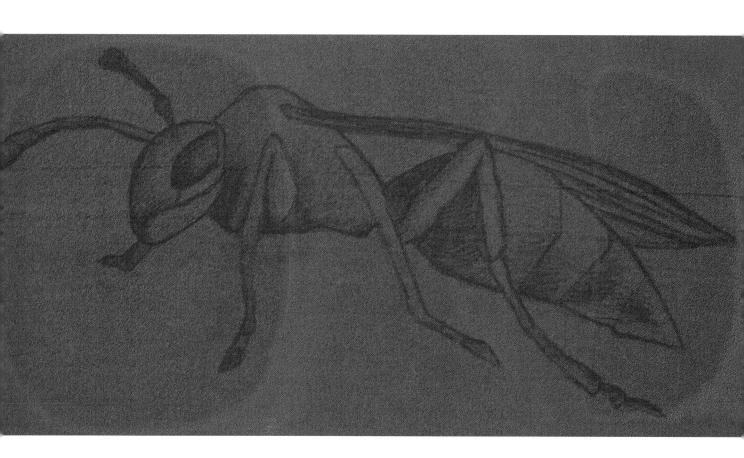

Wasp, Roni Henning

I tinted transparent base with black acrylic paint
and transferred a pencil drawing onto the paper. I
printed it at Henning Screenprint Workshop.

Ghost Imaging

Ghost images refer to the lighter third, fourth, and fifth printings from a screen painted just once. To make use of a ghost image, some artists repaint the same image on the screen and reprint it over the ghost in a variation of the original colors to create a series of prints. Darra Keeton likes to print different images over the ghosts, working on five or six pieces at a time. She then sets aside the ones she likes and continues working with them. Over those she didn't like, she printed entirely different designs.

Cleaning Up

After printing regular or ghost-image prints, scoop the base out of the screen into a container. You can reuse this base by mixing it with silkscreen ink to make it transparent. Spray the screen with water and wash it out with paper towels while it is on the table, or spray it with a hose in a wash-up sink. The stain, or ghost, will remain in the screen and can help if you want to add color to the same image. After you've used the screen for several different images, scrub the screen with cleanser or haze remover, though you will not get the stain out completely. When you no longer can work on the mesh, stretch new mesh over the frame. Cleaning the screen is shown on page 116.

Venus #1, **Regina Corritore**

Corritore printed this print first.

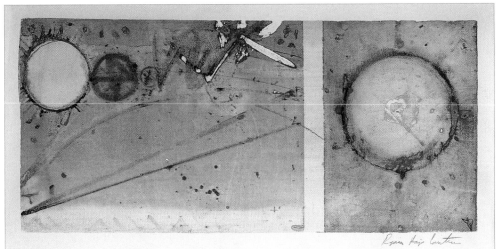

Venus #2, **Regina Corritore**

The screen was reflooded with base, and the lighter ghost image was printed.

Gallery of Monotypes

How Did You Two Meet?, James DeWoody

DeWoody painted and drew on the screen using on original photo as a guide.
I printed this screened monotype at Henning Screenprint Workshop.

Camouflage, **Richard Tsao,
11" x 15"**

Tsao drew and painted this
water-based screen monotype at
his studio.

Untitled, **Lynne Oddo**

Oddo painted this screened
monotype on 195-monofilament
mesh. I printed it at Henning
Screenprint Workshop.

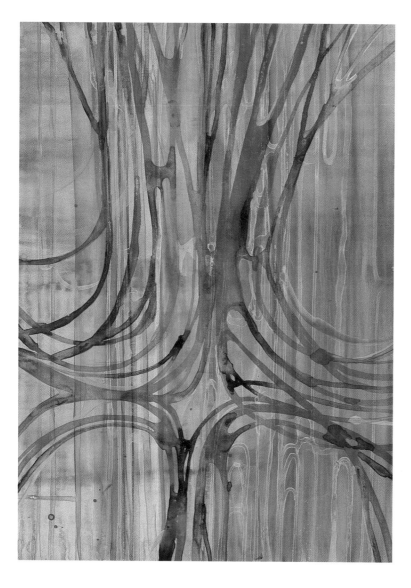

Untitled, Darra Keeton

I printed this screened monotype that was painted by Keeton with watercolor and water-soluble Caran D'Ache crayons.

Side by Side, Roni Henning

I made this monotype and screenprint combination using screenprinting inks, colored pencils and watercolors. I stretche the screen with white 230-monofilament mesh and printed it at Henning Screenprinting Workshop.

Untitled, Lynne Oddo

I printed this monotype, which was painted with watercolors and gouache, at Henning Screenprint Workshop.

Untitled, Susan Daykin

Daykin drew and painted this water-based monotype with watercolors and gouache on 195-monofilament white mesh. She printed it at her studio.

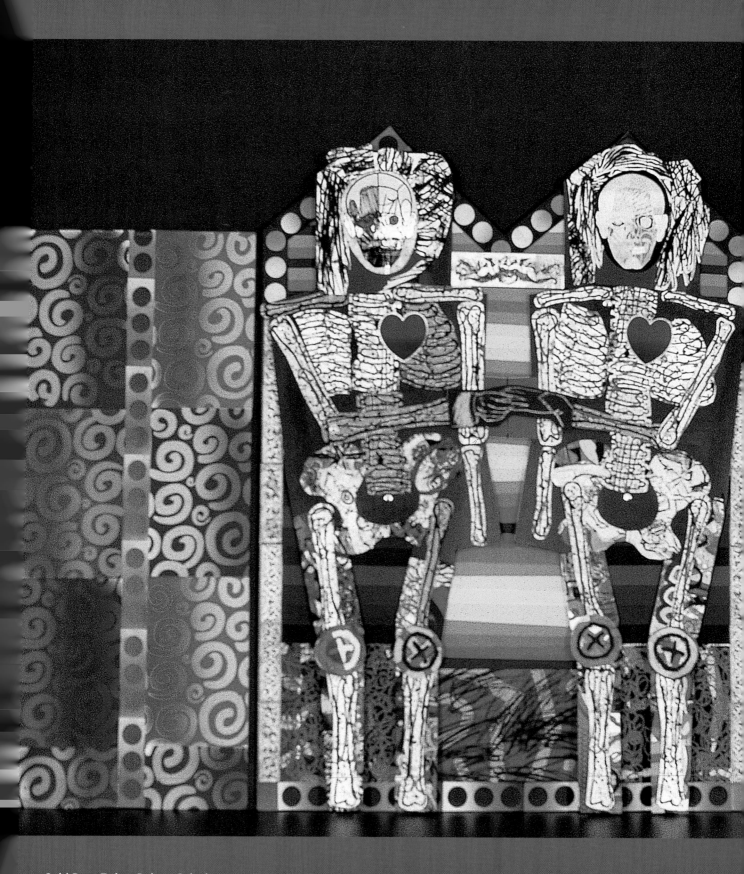

Gold Dust Twins, Robert Schwieger, 40" x 60" x 1"

This constructed screenprint was printed using water-based acrylic inks on various substrates. The print is from the collection of the artist.

3

Making Color Separations

There is a logic to color separations once you understand the process. To make a screenprint, you print one color at a time through the exposed mesh of a screen. A color separation blocks part of the screen so ink will print only in designated areas.

It is a creative process, not just a technical one. In the past, artists and printers used screenprinting to produce only flat or glossy, opaque colors, depositing a thick layer of brilliant color on any of many surfaces, including paper, cardboard, wood, plastic, foil, and fabric.

New technology in computers, emulsions, and inks now allows you to turn any piece of art into a screenprint. No image or textural effect is beyond its range. That feature, combined with screenprinting's rich color, makes it one of the most versatile printing methods.

How Color Separations Work

Color separations also can be called plates, positives, films, or stencils. They block out the negative space on the screen so the positive space prints when you force ink through the mesh with a squeegee. Each color has its own stencil, or color separation, and its own screen. So a print that uses three colors—orange, blue, and green, for example—requires three stencils.

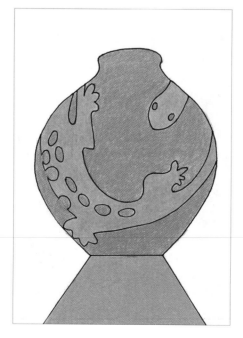

How a Screenprint Is Constructed

These drawings show how each color of a silkscreen is printed separately.

Choosing Colors

Analyze the original piece of art you want to print logically:

- Limit the number of colors you will use, whether for financial or time reasons.
- Study the art to see how it was made. If you are printing your own work, you can imitate your original painting process layer by layer to make the separations. Observe the amount of blended colors, the texture of the surface, and the style, whether abstract or representational. A four-color Ellsworth Kelley is easier to analyze than a Jim Dine or Chuck Close. If an artist incorporated photography into his or her work, make photo stencils on the computer (*see Chapter 7*) or have them made at a photo copying center, stressing that you'll be using them for screenprinting and need them to be opaque on film.
- Record the colors that dominate the picture due to the amount of color, contrast, or intensity. Mix small amounts of ink of each of these colors plus two or three more, and print several small samples of each. Then add transparent base to the colors and print the transparent colors over their respective opaque colors, recording the formula for each swatch. Also layer other colors together, again recording the formula for each new swatch to see what new colors you can create from the original few. You can create most of the colors from the original artwork this way. Keep track of the overlays for reference for making separations. Cut out the color swatches and mount them in the order in which you need to print them. You can mix any remaining colors you still lack from separate inks.

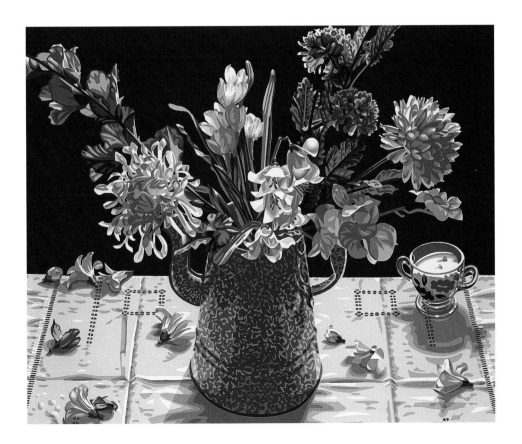

Blue Pitcher, Nancy Hagin

The separations for this print were handpainted on Lexan acetate and printed at New York Institute of Technology's Screenprint Workshop with oil-based inks. It is provided courtesy of Fischbach Gallery.

Layering Colors

I started with the eight colors at bottom, which I eventually overprinted to create nineteen additional colors (*see page 47*), to print this bird.

Original Painting

I started the color selection process for this painting by Dawn Henning with the eight swatches below.

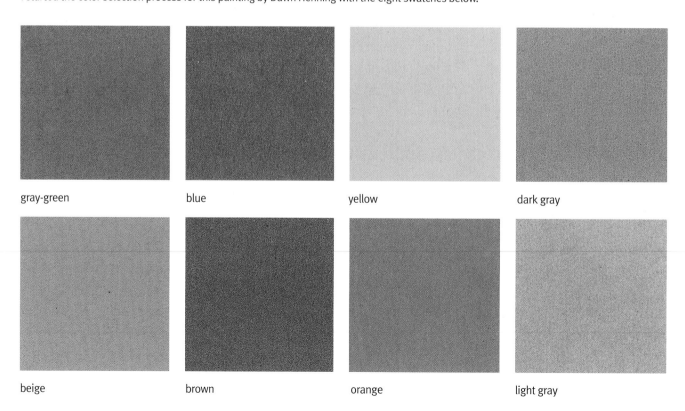

gray-green

blue

yellow

dark gray

beige

brown

orange

light gray

New Color #1

I printed transparent blue over green.

New Colors #2, 3, 4 and 5

I printed transparent yellow and beige over gray-green.

New Colors #6, 7 and 8

I printed transparent yellow and gray over gray-green.

New Colors #9, 10 and 11

I printed transparent yellow and gray over blue.

New Colors #12, 13 and 14

I printed transparent yellow and brown over blue.

New Colors #15 and 16

I printed transparent yellow and brown over gray-green.

New Colors #17, 18 and 19

I printed transparent orange over yellow and gray-green.

Applying Color to Separations

Apply one of the original eight colors to each color separation. As they overprint, the nineteen new colors also will begin to emerge.

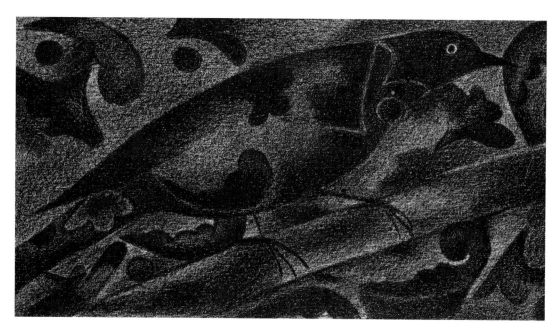

Separation #1

I handdrew this separation on textured acetate with a black China marker.

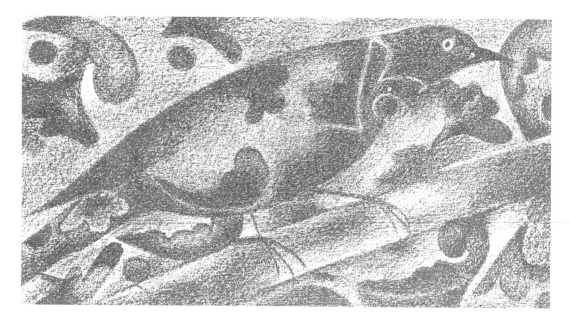

Color #1

I printed Separation #1 with gray-green.

Separation #2

I handdrew this separation on textured acetate with a black China marker.

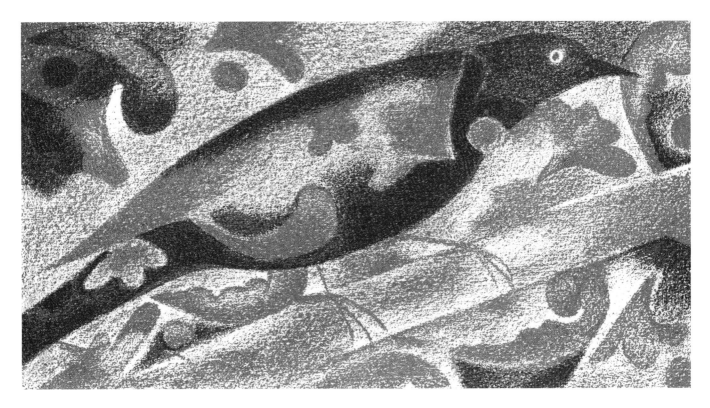

Color #2

I printed Separation #2 with transparent blue.

Separation #3

I painted this separation on acetate with opaque black watercolor.

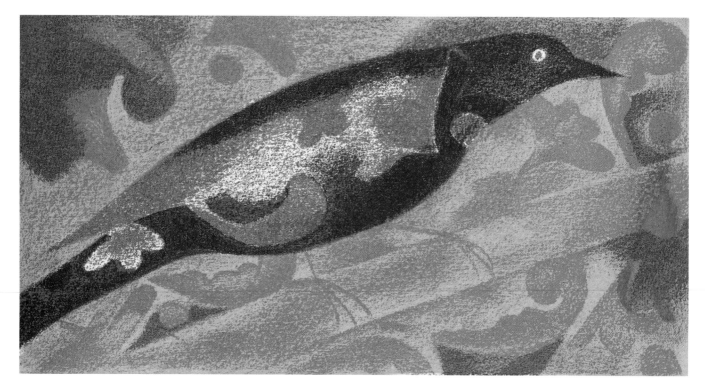

Color #3

I printed Separation #3 with transparent yellow.

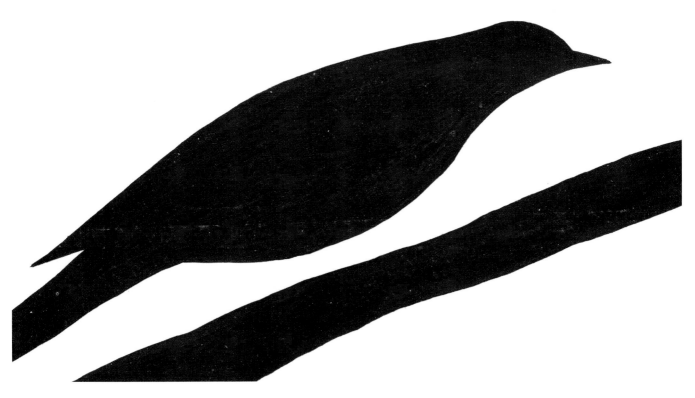

Separations #4 and 5

I painted both separations with opaque black watercolor, putting them on the same piece of acetate because they are separated.

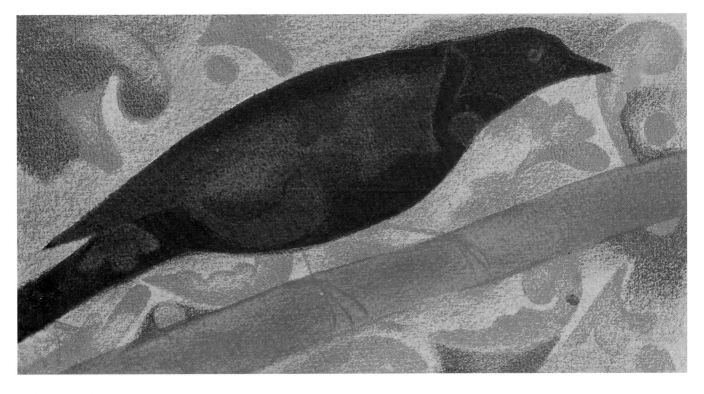

Colors #4 and 5

I printed transparent gray on the bird's body to soften the texture and transparent tan on the branch.

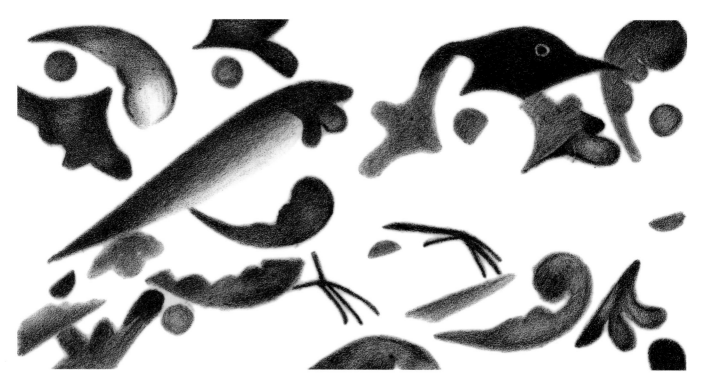

Separation #6

I handdrew this separation on acetate with a black China marker.

Separation #7

I handdrew this separation on acetate with a black China marker.

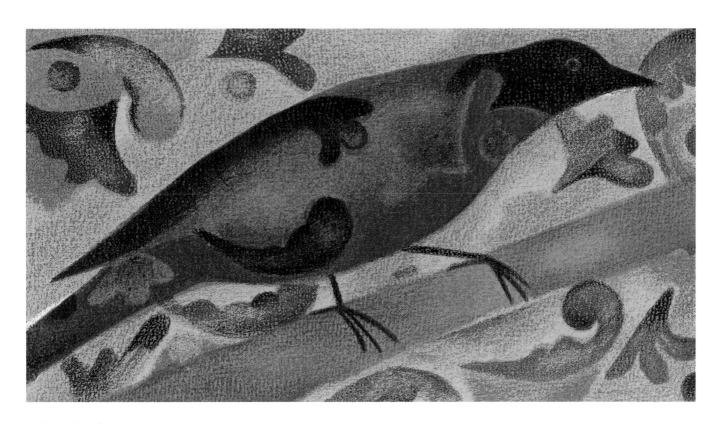

Colors #6 and 7

I printed brown from Separation #6 to add some darks. I printed orange on the branch through Separation #7.

Separation #8

I painted this separation on acetate with opaque black watercolor.

Separation #9

I handdrew this separation on acetate with a black China marker.

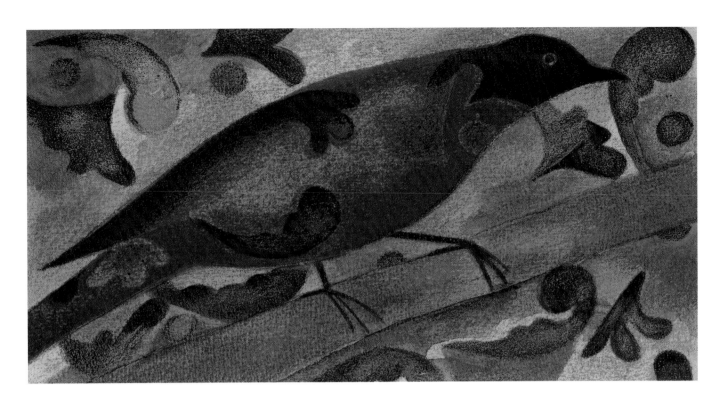

Colors #8 and 9

I printed Separation #8 with transparent gray and then Separation #9, to make the last, dark details, with brown to finish this interpretation of the original watercolor painting on page 46. This is an interpretation of the original watercolor. I stopped here, but I could have continued and built up the color layers even more.

Different Stencil Methods

You can make direct or indirect stencils. To make a direct stencil, you will work directly on the screen. You will make indirect stencils from separate materials, such as acetate sheets, paper, or photographic films, then transfer them to the screen with photo emulsion.

 Let your vision or imagination take over. If you are new to printing, do not start with an original or layout; instead develop a print by experimenting with the stencil methods on the following pages. See what methods or combinations of methods create your own style of painting or drawing.

 Develop the print as you would a painting. There is an excitement and freshness to this way of working. Screenprinting is just another technique, such as oil painting, collage, and drawing; though the process uses precision, it also leaves room to experiment.

Reduction Printing Using the Block Out Method: Print Color #1

Print beige over the surface. Then block out the areas you want to remain beige.

Print Color #2

Print yellow, then block out the area you want to remain yellow.

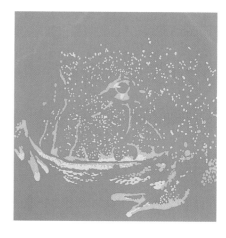

Print Color #3

Print light green; it will print over the entire surface except the spots you have preserved as beige and yellow. Now block out the areas you want to remain light green.

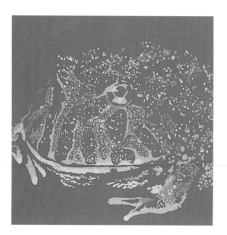

Print Color #4

Print medium green. As you block out more areas, less color prints. Block out the areas you want to remain medium green.

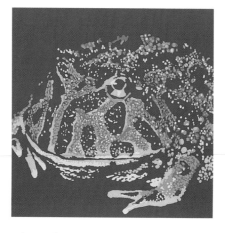

Print Color #5

Print dark green and then block out the areas you want to remain this color.

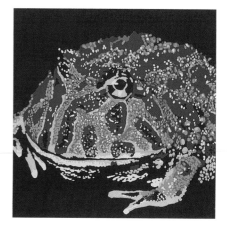

Print Color #6

Print dark brown, then block out the appropriate areas.

Direct Stencil Reduction Printing

Use screen filler or liquid emulsion made for use with water-based inks to paint out, or fill, the areas you don't want to print. I prefer to work with emulsion, which resists water after having been exposed to ultraviolet light or sunlight. You can apply emulsion using paintbrushes, sponges, or pieces of illustration board, as seen on page 30.

I made the print of the frog below using seven colors. Reduction printing uses one screen on which you block out an area, reducing the amount of open mesh for each successive printed color.

I used a photo for reference and began by drawing the size of the print onto the screen and blocking it out with emulsion, as described on page 30.

Print the lightest color first, never moving the screen in order to ensure exact registration since you will print each color on top of the one that preceded it. Clean the screen in place by removing the ink, then carefully and thoroughly washing the screen with a sponge and water until the mesh is clean. Dry it with a hair dryer and then continue. Use photo emulsion to block out the open space of the color you printed.

My lightest color, beige, appears in only a small part of the picture but I printed it over the entire square opening. Then I blocked out the parts I wanted to remain beige and printed yellow over the rest of the square. The frog began to appear when I printed the middle green. Print the last color, usually the darkest color, in the smallest open area. In this case, though, I finished with a light color, light sienna.

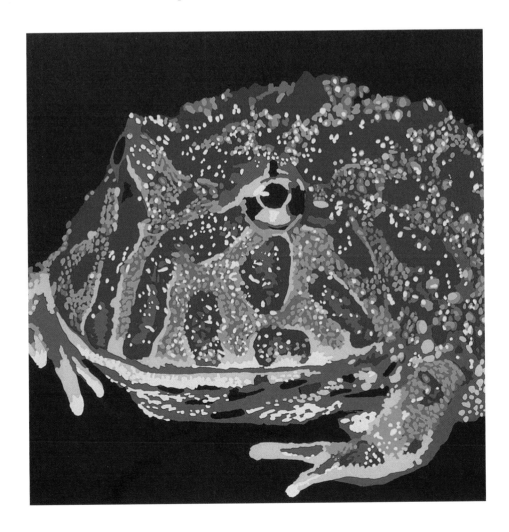

Frog, Roni Henning

Color #7, light sienna, was printed here to finish the reduction print.

Direct Stencil Positive Drawing Fluid

Positive drawing is the opposite of blocking out. For each color, paint the area you want to print using a thick layer of water-soluble liquid drawing fluid and a paintbrush. You can use any water- soluble fluid as long as it will resist the screen filler and has a good painting consistency. Make sure you purchase drawing fluid and screen filler together. two good brands are Speedball and Lascaux.

Dry the fluid thoroughly with a hair dryer or fan. Coat the screen with screen filler using a squeegee or scoop coater and dry thoroughly again. Place the screen in a washout stand and spray it with warm water to wash out the drawing fluid. The screen filler will remain in the screen, and the area where you applied the drawing fluid will remain open and ready for printing. Dry the screen, check for pinholes in the filler and touch them up with filler.

Clean the screen filler out of the screen with Greased Lightning or any quality janitorial product and repeat for the next color. The screen filler can be quite stubborn, so you might have to repeat the several times to get the screen filler out of the screen. Use a hose to wash the screen thoroughly.

Once you get used to the process, experiment spraying or spattering the drawing fluid with almost anything to see the patterns that emerge.

Draw the Image on the Screen

Draw directly onto the inside of the screen with a pencil and then drawing fluid.

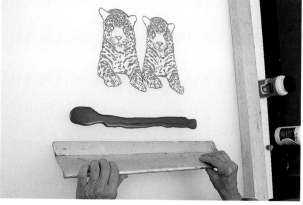

Prepare the Screen Filler

Let the fluid dry and pour screen filler into the screen.

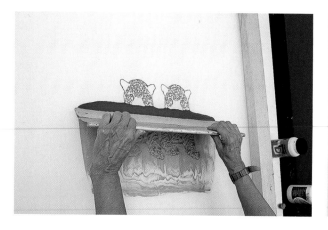

Coat the Image

Push the filler across the drawing using a scoop coater.

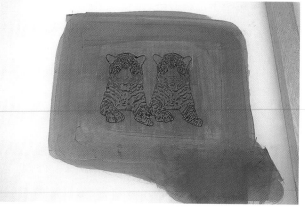

Recoat the Image

Coat the screen with filler several times and let dry.

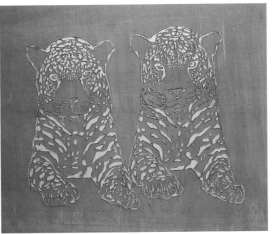

Wash Out the Drawing Fluid

Place the screen into a washup stand and wash the drawing fluid out, leaving the filler intact.

The Finished Screen

The open areas represent the areas where the drawing fluid had been. Some of the pencil lines are still visible.

Put Paper Under the Screen

Register paper under the screen.

Push Ink Over the Stencil

With the screen raised, push ink across the stencil using a squeegee.

Print the Ink

Lower the screen and print the ink by pulling it toward you with the squeegee at a 45-degree angle.

Final

Here is the finished print.

Direct Stencil Wax Crayon Rubbings

Draw directly onto the screen with wax crayons to create a negative textural print. The crayon blocks the ink so the image will print the opposite of what you have drawn. This method works best to make rubbings of textured surfaces like a window screen or wood grain. Make sure the screen has solid contact with the textured object as you rub over it with a wax crayon, using cardboard to prop the object up and adding weight to the frame.

Build up more crayon on the screen than you would on paper. Then fill in the screen outside the edges of the image you want to print with screen filler or emulsion.

Clean the ink out of the screen as described in Chapter 6. Remove the crayon with any spray-on household cleaner that indicates wax removal. Let it set to begin to dissolve the crayon, following the manufacturer's directions. Then wipe it off with a sponge or paper towels. If the wax is stubborn, try scrub brushes and powdered cleansers, such as Ajax and Comet. Remove emulsion using stripper or bleach.

Spirit Unbound — *Set Me Free*,
Kim Tester, 24" x 16"

Wax crayons were drawn on the screen to act as a resist for this reduction print. The crayons are applied in layers, one after each color run. The use of crayon instead of block out emulsion creates an uneven pattern similar to that created by oil pastels.

Draw the Negative of the Image You Want to Print

Draw directly on the inside of the screen using a wax crayon. Black and blue work equally well; the artist, Dawn Henning just liked the way the combination looked as she drew.

Flood the Image With Ink

Flood transparent blue ink across the image to fill the areas on which you didn't draw.

Examine the Print

The resulting print is the negative of the wax drawing.

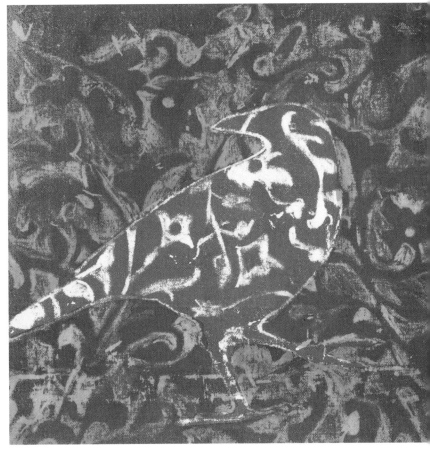

Hidden Bird, Dawn Henning

Henning printed a second layer of transparent blue over the bird with another screen.

Indirect Stencil Methods

You can make indirect paper, handdrawn or painted autographic, knife-cut, or photo-positive indirect stencils. Except for the paper stencil, each re-creates a distinctive style or image. You will make these stencils separate from the screen, unlike direct stencils, and transfer them to the screen by exposing them using photographic emulsion. Make sure the marks are opaque so they will transfer to the screen.

Indirect Paper Stencils

To make the easiest kind of stencil, paper, I prefer to use freezer paper, which you can buy at any grocery store. Cut out the shape you want to print using a stencil or craft knife. Place the paper, which will seem floppy and unstable, shiny side up under the screen. Dab small amounts of transparent screenprinting base on several spots of the stencil, then press the screen down firmly so the paper sticks to it, and apply masking tape so the stencil will stay in position until you flood the screen with the ink, at which point the ink itself will adhere the stencil to the screen.

Unlike acetate or film, you cannot re-use paper stencils because cleaning the ink out of the screen destroys the paper. The edges of a paper stencil image will appear slightly darker than the rest of the color because of the thickness of the paper.

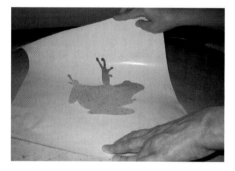

Make a Stencil

Cut a stencil out of freezer paper with the shiny side up.

Put the Stencil on the Screen

Press the paper stencil, shiny side up, onto the screen with a few dabs of transparent base.

Keep the Stencil in Place

Place some masking tape on the corners of the stencil to keep it still until you print the ink.

Check the Stencil's Position

Check that the stencil is positioned correctly.

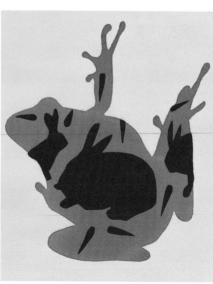

The Final Print

I made this three-color print using one direct block-out stencil and two paper stencils.

Indirect Autographic Stencils

Draw or paint on separate sheets of textured or smooth, clear or frosted acetate or tracing paper. The surface of textured acetate grabs the crayon and breaks it up into an opaque, randomly textured mark that resembles lithography. Tracing paper creates a similar effect.

What you paint or draw is what will print. The painted shape becomes the open area through which you will print. Transfer the stencil to the screen following the directions in Chapter 4.

A screen can print only solid flat colors, so this method allows you to block out tiny bits of the screen, creating texture without photography. Paintings, drawings, pastels, and watercolors that you would want to print usually contain some texture, blended color, or continuous tone, and other than photographic stencils, handdrawn or painted stencils achieve these qualities best.

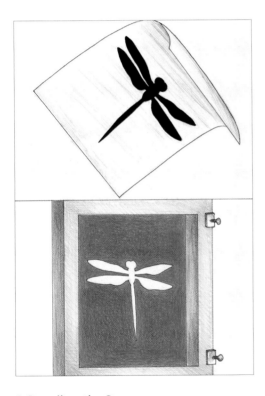

A Stencil on the Screen

A painted color separation produces the same-shape opening on the screen.

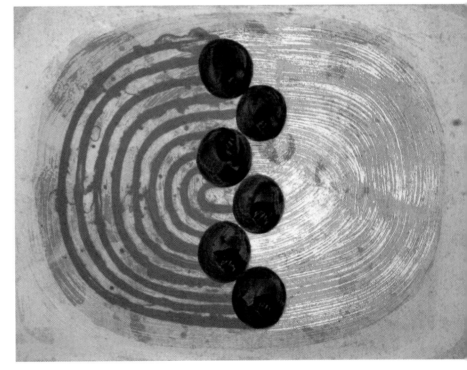

***Stepping Stones*, Steven Cushner**

The dimensional quality of this print is heightened because areas of the image were overprinted with translucent fields of color that are then blotted with newspaper, revealing textures created by the traces of ink left in the recessed areas. It was printed by Dennis O'Neil at Hand Print Workshop International.

Painting Acetate Indirect Stencils

Draw or paint on the acetate with a variety of materials—spray paint, black opaque paint, pen and ink or black China markers, which are more opaque than black lithographic crayons—on textured acetate or fine, smooth acetate rubbed with fine sandpaper. Also try scratching away painted or drawn areas with a razor blade or a stencil knife to create other textural effects.

Acrylic paint makes nice brush marks. Lithographer's opaque is easy to paint with but requires a small drop of dishwashing detergent to make it adhere to the acetate (too much will make it sticky). Spray paint will create a nice transition from light to dark, and sponges make interesting textures. Any opaque mark will transfer to the screen.

Lascaux makes tusches, available from Graphic Chemical and Ink Company, that print to look like watercolor washes and resemble lithographic tonality, but the particles, though small, are opaque and do expose and print accurately. They are watery and thus hard to control but work best for abstract effects, especially when built up in transparent layers. Lascaux also makes spray tusches. Use a very fine screen like 305-monofilament mesh to hold the tiny particles.

Lithographer's Opaque

China Marker

Pro-Black Opaque Watercolor

Sanded and Scratched Surfaces

Black China Marker Rubbings

Spattered Ink

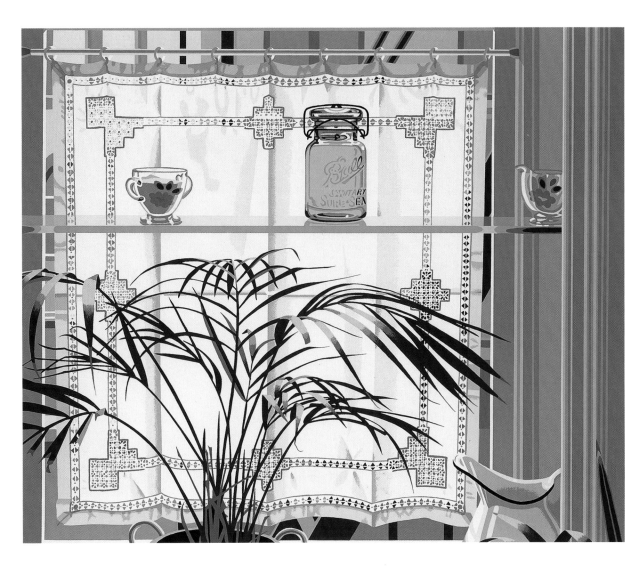

Lace Curtain, **Nancy Hagin**

The separations for this print were painted on textured acetate with lithographer's opaque, and I printed it at New York Institute of Technology's Screenprint Workshop with oil-based inks. The print is provided courtesy of Fischbach Gallery.

Lascaux Tusche Washes

At far left is a Lascaux tusche painted on acetate. A screen was made from that acetate and the image at near left was printed from that screen.

Using Multiple Stencils Together

Trapping

When you are printing one color next to another, overlap them slightly. This technique is called trapping because you trap one color under another where they meet. This overlap insures against the stretch of the screen and weather-caused paper expansion and contraction to avoid blank spots between the colors.

Plan your separations with this in mind. The color order is very important. The first color should be exact everywhere except where it meets the next color, at which points you should make the separation larger. The second color will overlap the first at these points. The third color overlaps the second and first and so on.

Registering Stencils

To make sure your stencils print exactly where you want them to, including the area you planned for trapping, register your color separations.

You can buy tape with registration crosses in any art store. Place the crosses on the original art, then lay each stencil over the original art one at a time and add crosses to the stencils in the same spot. Then place the pile of stencils, in order of separation, on a light table. They should fit together like a jigsaw puzzle. Light should not show through the edges of the stencils if there is enough trapping.

Or make a detailed drawing as your first stencil to serve as an alignment guide for all the successive stencils. I prefer this method for soft, handdrawn stencils because it helps me visualize the finished print. You also could print the master drawing first, then draw the color separations directly from this print, which more accurately depicts how the screen will continue to print the image than the master drawing itself does.

Creating Continuous Tone

Draw several separations on textured acetate to create the illusion of continuous tone. First print a base color over which to print the texture. Plan the first separation to be the densest and most complete and the lightest color. Each successive stencil should use diminishing texture and a darker shade. Printing transparent colors will create a blend from light to dark.

Trapping *(left)*

Apply the first color, in this case red, to an area bigger than where you want it to appear. Then print a second color, in this case blue, slightly overlapping the first. The dotted lines in this image represent the area I printed with red.

Registration Cross *(right)*

Place these crosses in the same places, usually in the corners, on each separation to align them.

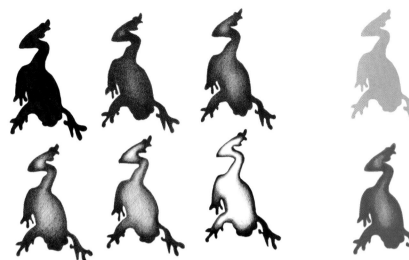

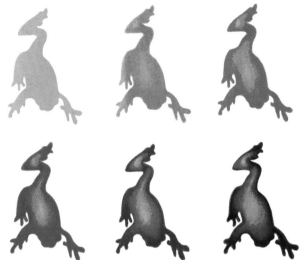

Drawing to Create Continuous Tone

I drew these six separations on textured acetate using a China marker and ink. The black frog translates to the lightest print proof at right. The last separation with the least drawing printed the last, darkest blue.

Printing Continuous Tone

These six progressive proofs show the buildup of transparent colors, creating the illusion of continuos tone.

Untitled, Elizabeth Osborne

The separations for this print were handdrawn on textured acetate with black China markers.
I created the print with oil-based ink at New York Institute of Technology's Screenprint Workshop.

Indirect Knife-Cut Film Stencils

Rubylith and Amberlith films are used to create stencils with sharp-, hard-edged shapes. Cut the top, dull layer with a stencil knife, making sure not to cut all the way through the backing by using light pressure. Peel the top layer, what you don't want to print, away.

For this and other indirect stencil methods except paper stencils, you will next apply the stencil to a screen that you have prepared with photo emulsion.

***Davy Jones Locker*, Gene Davis**

The color separations for this print were hand-cut with a stencil knife and printed with oil-based ink. The print is provided courtesy of the Smithsonian American Art Museum.

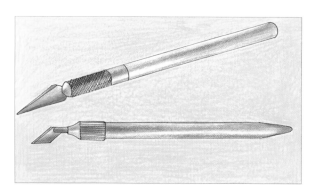

Stencil Knives

Cut the Rubylith Film

Cut through the dull side that faces up. Do not cut through the backing.

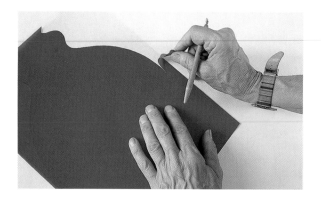

Remove the Film

Peel the film from the backing to create a positive stencil separation.

Stencil Separation #1

This stencil will print a solid, rectangular background.

Stencil Separation #2

This stencil will print the vase.

Stencil Separation #3

This stencil will print the lizards.

Resulting Prints

Printed in succession, the stencils at the top of the page created each of these prints.

Photo-Positive Film Stencils

In the past, photo stencils were made with high-contrast Kodalith film because of its opaque blacks, It is perfect for screenprinting and for use with copy cameras and photo enlargers.

Commercial photo labs can make photographs into halftones, dot patterns like newspaper pictures, or high-contrast line shots. They then break them down into four-color separations of yellow, magenta, cyan, and black, like commercial publications.

Today you also can make photographic stencils using computer software like Adobe Photoshop (*see Chapter 7*).

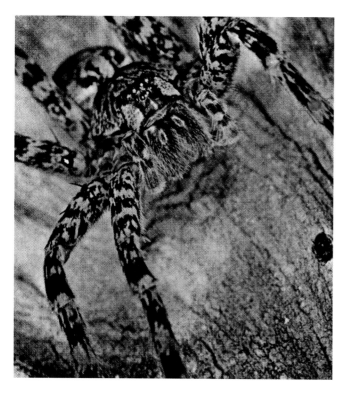

Photo-Positive Film Halftone Separation

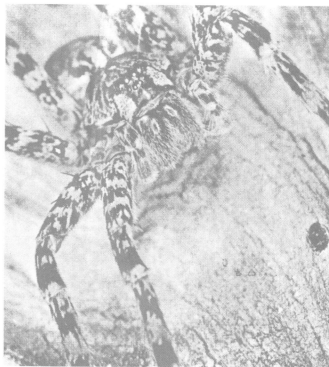

Print from the Halftone Separation

Charms, Stephanie Hunder, 17" x 40"

The first two sections are screened from random dot films from original photos (16 to 20 colors).
The last two are serigraphs from digital films from scanned in objects (10 to 14 colors).

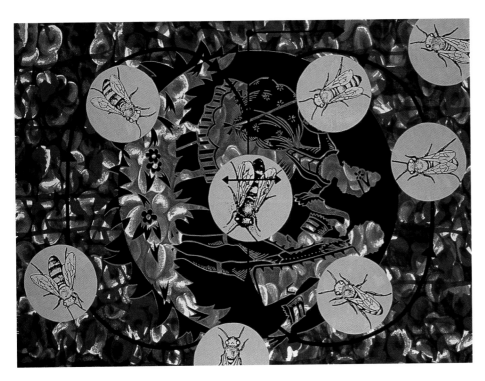

Language of Dancing, Kathryn Maxwell, 20" x 28"

The positives for the stencils for this print were created with Rubylith film, handdrawn stencils, or appropriated images, which were manipulated on a computer or photocopy machine. The print is provided courtesy of the artist.

#618 Tradecraft Concealments, Allison Smith

The positives for this print were made with Rubylith film, photocopies, handpainting, and ChartPak tape. It was printed with TW graphics water-based inks, cut out, scored, and assembled into a box. It was published by the Lower East Side Printshop.

4

From Stencil to Screen

To transfer a stencil to a screen, coat the screen with light-sensitive photo emulsion. Apply the emulsion under a yellow safe light even though the emulsion is not as sensitive as photographic paper. Place the opaque color separation in tight contact with the coated screen and expose it to ultraviolet light. The light hardens whatever emulsion the separation does not block and leaves the rest soft. Remove the stencil and wash the soft emulsion away with water, revealing the shape of the separation. The ink prints through this open area. What you paint on a color separation becomes the stencil and is what will print.

The exposure time needed is determined by the type of stencil you use, how you coat the emulsion onto the screen, and the light source you use.

Applying Emulsion to the Screen

Use all emulsions under a yellow safe light. Screen emulsions are water-soluble when liquid, and you can remove them with water and stripper or bleach. Choose emulsions that specify use with water-based inks, or they might deteriorate during printing. These emulsions have a longer shelf life before you combine the two parts: a liquid base and a sensitizer. Follow the directions for mixing. Some come with a dye to make them more visible on the screen. I use Ulano 925 and Ulano TZ with excellent results. RLX also is a good choice. Try different emulsions to see which works best with your imagery and exposure system.

Degrease the screen before coating it with emulsion to remove the oily residue so the emulsion will flow evenly and smoothly. You can find degreasers at any screen supplier, or use an abrasive cleanser like Ajax or Comet with a stiff nylon scrub brush. Water should flow and sheet smoothly, not bead up on the screen. Then dry the screen thoroughly in front of a fan before applying the emulsion. If you used cleanser that has bleach, neutralize the screen with white vinegar. Then wash and dry it again before coating.

Lean the screen against a wall with the flat side facing outward. Wedge the screen under a nail or pushpin to prevent the screen from moving when you apply the emulsion. Pour the emulsion into the scoop's well, but do not fill it. Place the scoop against the mesh at the bottom of the screen and lean it forward while pushing slightly into the screen. Make sure the scoop fits within the wooden frame and rests only on the mesh.

Grip the lip evenly with both hands and draw the emulsion up to the top of the screen. You should be able to see the emulsion fill the mesh as one color, without lumps or streaks. At the top of the screen, tilt the scoop back toward you while keeping it firmly pressed against the screen and then remove it to prevent emulsion dripping from the scoop to the screen. For a heavier deposit of ink, use more emulsion to create a thicker stencil. If you need to apply a second coat, apply it to the other side of the screen using the same method.

Make a scoop card by cleanly cutting pieces of cardboard or illustration board, and fill in the mesh on the sides of the screen where the scoop did not reach. Make sure you cover the entire mesh.

Place the coated screen in front of a fan to dry thoroughly. You can dry it longer or overnight if you do so in a dark place. Read the manufacturer's recommendations to see how long the coated screen can last before exposure. Thicker applications of emulsion require longer drying time.

Scoop Coaters

Apply photo emulsion using one of these kinds of scoop coaters. Both work well; the one with sides prevents the emulsion from spilling.

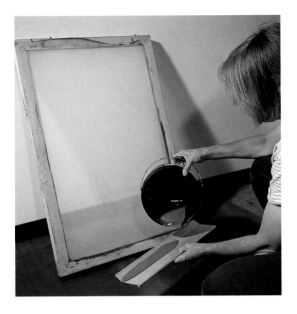

Prepare the Screen and Emulsion

Lean the screen against a wall and wedge it under a pushpin or nail to keep it still. Pour photo emulsion into a scoop coater.

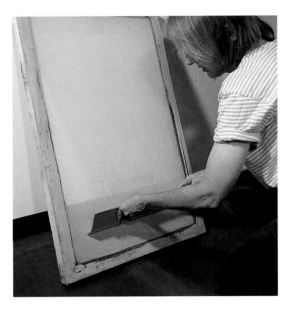

Position the Scoop Coater

Press the scoop firmly against the flat side of the screen.

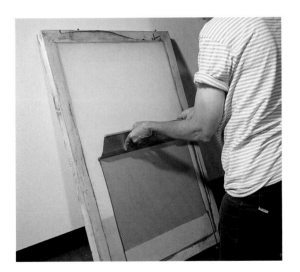

Pull the Scoop Coater

Pull the scoop up along the screen applying even pressure.

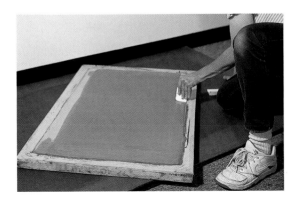

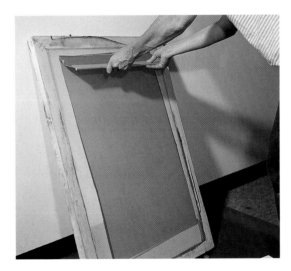

Catch the Emulsion Drips

Pause at the top of the screen to let the emulsion flow back into the scoop before removing it to prevent drips.

Coat the Rest of the Screen

Coat any remaining unexposed parts of the screen using illustration board cut into cards.

Exposure Unit with a Separate Light Source

A vacuum frame, usually a glass and steel case with a rubber blanket and vacuum unit, holds a coated screen and a color separation in tight contact with each other. Place the coated screen in the frame and lay the rubber blanket over it. The vacuum will force the blanket to squeeze around the screen. Swivel the unit to an upright position so the screen faces the light source.

Set a metal halide light system, which comes in different wattages and with a stand or overhead mounting bracket, in front of the vacuum frame at a distance equal to the stencil's diagonal. The light sits behind the shutter, which operates on a timer, when you turn the lamp on. A built-in fan keeps the lamp cool. Set the timer to the desired exposure, as few as twelve seconds, and turn it on. The shutter will open, expose the screen and close. Leave the lamp on until you have exposed all screens. After turning it off, let it cool before turning it back on.

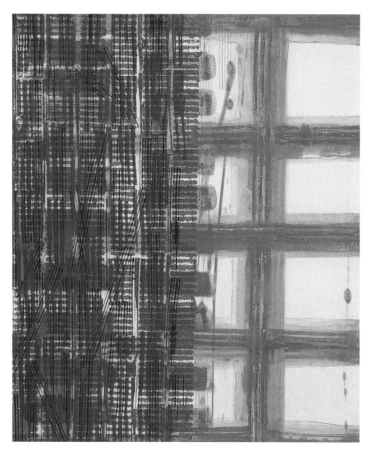

Untitled, Jon Pengelly

Pengelly printed this screened monotype with one photo stencil at New York Institute of Technology's Screenprint Workshop.

Separate Vacuum Frame

You can see the reflection of a halide light in this vacuum frame as a screen is exposed.

Metal Halide Light

The light exposes the image onto the screen.

Exposing the Screen

Tape the separation to the dry, emulsion-coated flat side of the screen with at least three inches between each side of the separation and the screen. Place the separation backward on the screen so it reads correctly when you look into the screen from the front.

Place the screen, separation side down, onto the exposure unit's glass. Close the vacuum frame, making sure they are in very tight contact. Turn the unit on and wait for the rubber blanket to suck around the frame of the screen. When it exhausts all the air, swivel the unit to a vertical position so the flat side of the screen with the coated stencil faces the light.

Separation Taped to the Back of a Screen

Leave at least three inches between each side of the separation and the screen.

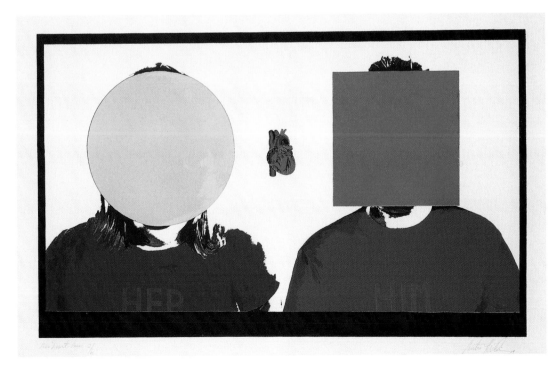

***Him Heart Her,*
Curtis Miller**

Miller made the separations for this image by hand. The print is provided courtesy of the artist.

Exposure Unit with Built-In Light Source

This unit holds a number of ultraviolet tube lights in a glass case so you do not have to set up a separate light source. Place the screen on the glass with both the flat side and the taped separation facing the lights, and close the frame so the rubber blanket tightens over them. Turn the lights on. This system limits the size screens you can expose.

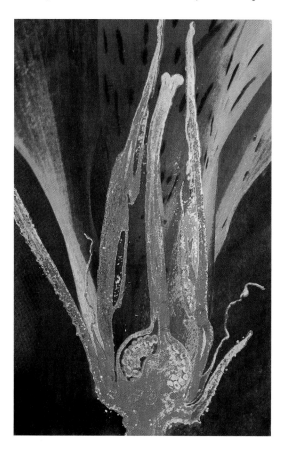

Remains, Stephanie Hunder

Hunder coated the screens for this print with Ulano TZ photo emulsion and made the film stencils with a random dot pattern. She printed it with Speedball water-based inks.

Untitled, Lynne Oddo

Oddo painted this monotype by hand with watercolors and gouache. I made the print at Henning Screenprint Workshop. The print is provided courtesy of the artist.

Professional Exposure Unit

The Lower East Side Printshop's exposure unit.

Handmaking Exposure Systems

Once you understand the principle behind making a screen, you can devise a method, without buying expensive equipment, of creating a tight contact between the screen and color separation. Though not perfect, the following methods work well.

Place a photo floodlight, found in photography or screen supply stores, in an aluminum reflector, and suspend it over a table that has a top that is smaller than the screen on all four sides. Cover the table with a two-inch thick piece of foam rubber. Tape the stencil to the back of the screen with Scotch Magic tape. Lay a piece of ½-inch-thick plate glass over it. The weight of the glass ensures tight contact between the screen and the stencil.

Or, build a box frame with 2- x 4-inch pieces of wood, using a ½-inch piece of glass for the top of the box. The bottom of the box should be one foot below the glass. Purchase eight or more fluorescent bulb fixtures with cords at home improvement stores, and replace the fluorescent bulbs with ultraviolet bulbs. Lay the fixtures next to each other on the shelf, and plug them into a power strip. Cover the sides with plywood to enclose the lights.

Place the emulsion-coated screen, with the separation taped to it, flat side down on the glass. Cut a clear acrylic sheet to fit on the inside the screen. Place bricks, weights, paint cans, or any other heavy objects on the acrylic, distributing the weight evenly to make a close contact between the screen and the separation.

Homemade Exposure Unit #1

Place a piece of foam on the table. Hang the screen over all four sides of the foam. Tape the color separation to the flat side of the screen. Cover the screen with glass and expose it using a photo floodlight.

Homemade Exposure Unit #2

Place ultraviolet lights on a shelf under glass. Place the screen and color separation on the glass top. Place weight on the layers to ensure tight contact.

Experimenting with Exposures

Expose a screen for a shorter time to hold the detail and a longer time for solid shapes. If the detail is the paper's white space, not the drawn or painted marks, it requires a longer exposure time. The longer you expose a screen, the more the light will seep in around the edges of the color separation, shrinking the image when you wash out the screen because less detail remains soft. Of course, too short an exposure will not harden the emulsion properly and will wash away, causing ink to print in areas where you do not want it.

Use fewer coats of emulsion when exposing for a shorter amount of time and more emulsion with a longer exposure time. If using a halide light, a short exposure could be ten to fifteen seconds. A short exposure with a photo floodlight could be ten minutes.

Experiment with exposure times and the amount of emulsion: Coat each of four sections of a screen with one to four coats of emulsion. Then expose one stencil overlapping all the sections. Repeat with different exposure times, keeping a record for comparison. Wash out the screens and compare the exposed areas in each section to the stencil to see which combination of exposure and emulsion achieves the best result.

Heads of State,
**Kathryn Maxwell,
17 ¼" x 17 ¼"**

The positives for the stencils are created with Rubylith film, handdrawn on acetate, and photo stencils.

Exposure Times

Here are some general guidelines for Ulano TZ and Ulano 925 emulsions.

- Expose fine detail, crayon or halftone with one coat of emulsion when using a strong halide light for twenty seconds or less.
- If you're using ultraviolet lights, expose the screen for one minute or less time.
- For a homemade system with photo flood lights, expose the screen for ten to fifteen minutes.
- For a homemade system with ultraviolet lights and weights, expose it for two or three minutes.

Remember, if you used more than one coat of emulsion, extend the exposure times. For separations made with thin paper instead of film or acetate, extend the exposure time dramatically to let the light pass through. I have extended exposure time from 45 seconds to six minutes for a paper separation.

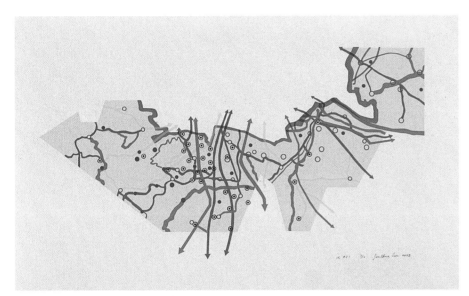

Information Retrieval #80, (Vienna bound), Geraldine Lau, 25" x 37"

Tri-Lon imaging printed digital Kodalith films from the computer at half size. The films were enlarged and photocopied onto vellum paper, which served as film positives for screenprinting. Courtney Healey and Dusica Kirjakovic printed it at the Lower East Side Printshop. The print is provided courtesy of Lau and the Lower East Side Printshop.

Vanity Fair Series No. 18, BABEL, The Work Continues, Timothy High, 15" x 20"

Timothy High printed this original hand-reduction serigraph with acrylic gloss medium resist at Terra Rosa Studio in Austin, Texas.

Washing the Screen to Reveal the Image

Even a bathtub with a spray hose attachment can serve as a washout stand, at least for small screens. Professional shops would use a metal washout stand with huge troughs, a high back and sides, a low front, a drain, and a spray nozzle hose attachment. Some have built-in backlighting so you can see the emulsion wash out more clearly.

Under yellow safe lights, take the exposed screen out of the vacuum frame and remove the stencil, saving it for registration. Put the screen in the washout stand with the flat side facing outward. Wet the back of the screen with a fine spray of lukewarm or cool water, washing it until you start to see the image appear. Then turn the screen over and spray the front side. Wash until the white tone disappears from the image.

Repeat until the mesh is visible, though the difference is subtle. If it looks clean, no more emulsion is washing out, and the surface is not slimy to the touch, you have washed it out enough. Hold the screen up to the yellow light to see if a thin residue of emulsion is still on the screen. If the screen does not compare to the stencil, continue washing.

When you are finished, lightly wash the screen with cold water and place it in front of a fan to dry.

Water Conservation Method

You can also wash screens out with water, a sponge, and a spray bottle. Wet the screen with a sponge and warm water. Keep a bucket of warm water for wetting the sponge and an empty bucket into which to squeeze the dirty water. Do this until the image begins to appear. Wash both sides of the screen, spraying directly into the stencil area until the emulsion washes out. In addition to conserving water, this method provides better control over detailed areas.

Professional Washout Stand

The Lower East Side Printshop's washout stand.

Washing the Screen

Wash the screen until the area where the emulsion has washed off looks like the stencil.

Touching Up the Screen

Look through the dry screen toward white light to search for pinhole points of light in the hardened emulsion. Dust on the glass of the exposure unit can block the emulsion from exposure and open up when you wash out the screen. Touch up such areas with emulsion using a paintbrush or a scoop card. Dry the screen one more time with a fan or hair dryer, then re-expose it. I usually put it in front of a halide light for five minutes. You do not need to create a tight contact since you already have shot the stencil.

Troubleshooting

The screen could open up in undesired areas because:

- you washed with water that was too hot.
- you underexposed the screen.
- the coat of emulsion is uneven or too thick.
- the emulsion is too old.

The screen might not wash out of the stencil areas because:

- you underwashed the screen.
- you exposed the screen for too long.
- you applied too thin of a coat of emulsion.
- the emulsion is too old.

Sometimes you might not notice a small amount of emulsion in the exposed mesh, which will block the passage of the ink through the screen. To test, lay the screen on your printing table and spray the open area with water on the printing table. If the water does not come through the screen, reshoot the screen.

***Doxycyloia: City Safe Evacuation Plan. . .2004*, Dannielle Tegeder, 26"x 72"**

Architectural blueprints and technological sketches inspire Tegeder. James Miller and Courtney Healey printed on Stonehenge natural paper at the Lower East Side Printshop. The print is provided courtesy of Tegeder.

Gallery of Prints

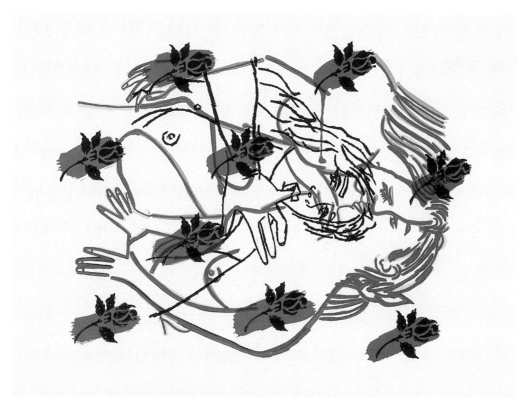

The Roses, Ghada Amer, 22" x 30"

The film positives for this print were made by hand using various opaque materials on frosted mylar. It was printed on Rives BFK paper at the Lower East Side Printshop. The print is provided courtesy of Deitch Projects and Gagosian Gallery.

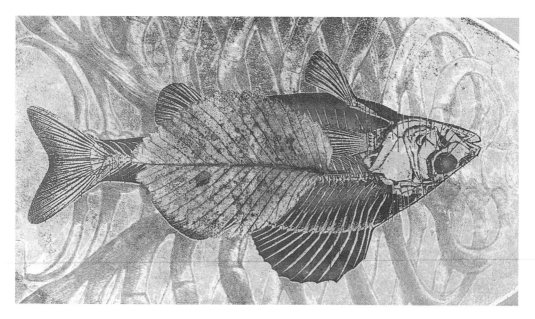

Poisoned, Stephanie Hunder, 22" x 12"

Digital films were made from an original photo of a leaf, and two appropriated drawings were combined with photo stencils made from drawings on transparencies.

Heir / Air / Loom: "Eyes and Ears", Wennie Huang,
18" x 18" x 18"

This print was made with scanned images of the artist's maternal and paternal grandparents that were manipulated with Adobe Photoshop software. The images were enlarged and printed on vellum and screen-printed on silk fabric using TW Graphics water-based inks. Huang then sewed the silk together. It was printed at the Lower East Side Printshop.

EMERGENCE—i am, Kim Tester, 72" x 36"

This reduction print uses wax crayons as the resist. Tester printed using only one screen and water-based inks.

5

Color Mixing

Color is a property of light. When Sir Isaac Newton shined white light through a glass prism, the light coming through the other side broke into a rainbow of hues. Objects actually have no color, only the ability to reflect certain rays of white light, which contains all the colors, in different ways, like the prism. For example, objects that look red really just absorb all the rays on the spectrum except red, which the objects reflect back to your eyes. Black objects absorb all of the rays and white objects reflect all of them.

The person who doesn't respond to color is rare. It evokes an emotional response, certainly from artists and printmakers. Josef Albers, the great American painter, devoted a career to the study of color. Most art students have made designs using Albers' theories of how colors change based on the color or colors adjacent to it.

All color theories apply when you work with screenprinting inks, just as they do when painting with oils and watercolors.

Water-based inks do not yet match the color variety of oil-based inks available, but the absence of solvents and fumes and the fact that they mix easily and clean up with just water makes up for the difference.

And they try, Gustavo Fermin, 15 x 22

The background was made with various stencils that were made with salt, opaque ink, and water on frosted mylar. The hands on the left were printed with a halftone stencil and the hands on the right were printed with transparent base and flecked with pearlescent black pearl powder to make the image appear. It was printed on Rives BFK paper by Fermin and Dennis O'Neil at Hand Print Workshop International.

Water-Based Inks

Mix ink in plastic containers, which do not rust, so you can wash out wet ink or peel out dried ink and re-use the containers. Like most printers, I use one or two brands. I have found that the opacity between brands is generally consistent, while the toxicity differs. Each manufacturer supplies a materials safety data sheet for its inks.

Traditionally, crafts and textile printing had been the only outlets for water-based inks, which had a tendency to buckle paper, causing registration problems. The choices for a serious artist or printmaker were few. However, the past ten years have seen great improvement in the quality of inks made for paper.

Making Opaque and Transparent Colors

For a system that resembles oil-based ink printing, I prefer Standard SAQ Water-Based Poster inks, which have nice opacity and a matte finish, and TW Graphics inks, which come in quarts and gallons. TW 1000 also has a matte finish and comes in eleven standard colors, eleven single mixing colors, and the four process colors—cyan, yellow, magenta, and black—for printing standard four-color halftones. It prints well on coated and uncoated paper and cardboard. TW 4000 and TW 5000 also have matte finishes and work well on other substrates, such as vinyl, laminates, and wood.

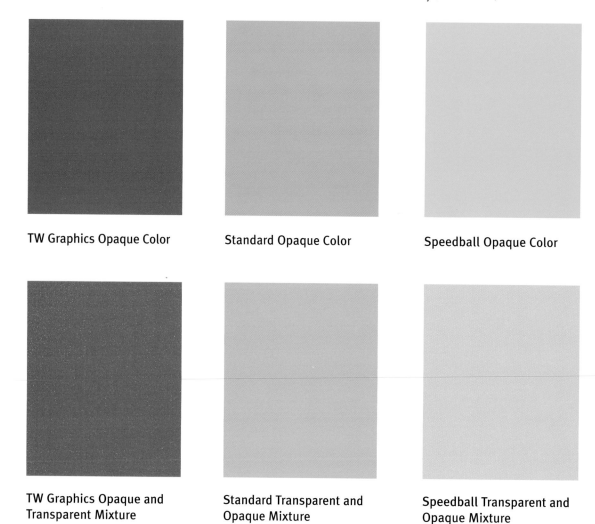

TW Graphics Opaque Color

Standard Opaque Color

Speedball Opaque Color

TW Graphics Opaque and Transparent Mixture

Standard Transparent and Opaque Mixture

Speedball Transparent and Opaque Mixture

Vanity Fair Series No. 19/Artist, Teacher, Surgeon, Timothy High, 22" x 15"

High printed this four-color-process photo serigraph at Terra Rosa Studio, Austin, Texas.

Createx Opaque Color

Createx Transparent and
Opaque Mixture

Standard, TW Graphics, and Speedball Acrylic Screenprinting inks produce opaque colors. Add transparent base to opaque colors to make them transparent.

Lynwood Kreneck, an art department professor at Texas Tech University, formulated Lyntex base specifically for mixing with Createx pure pigments, including pearlescent, which gives a metallic sheen. To make Createx pigments opaque, combine them with gouache or titanium white.

Most of the inks mentioned now have process colors—cyan, magenta, yellow and black—and are formulated to work with four-color halftone separations.

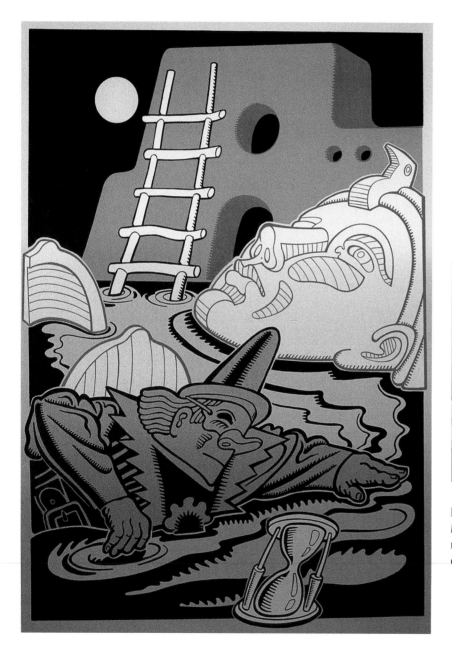

Plastic Containers

Mix your inks in plastic containers, which do not rust and are re-usable without the risk of contaminating your ink.

***Swimming the Santa Fe Nile*, Lynwood Kreneck, 18½" x 13"**

Kreneck printed Lyntex inks by Createx and Hunt Speedball. Eleanor Kreneck photographed the print.

From the Suite Print Fields, Nancy Blum, 30" x 20" each

Silkscreen ink was spread onto the paper with a squeegee (no screen) in a wavy pattern. Blum handpainted film positives of four circle patterns. The films were made into screenprints and printed with TW Graphics water-based overprint clear ink. The additional flower drawings were scanned into a computer and printed onto acetate sheets. The screens were made and printed with eight custom-mixed TW Graphics inks. It was printed at the Lower East Side Printshop.

Avatar 3, Lise Drost

Drost printed this combination litho and screenprint with Honco Litho inks and Speedball and Nazdar screen inks. The print is in the collection of the artist.

Mixing Colors

Follow all of the same rules as you would for acrylics, oils, and watercolors. Most screenprinting inks come in black, white, and primary and secondary colors, usually in a few shades of each color, for instance: lemon, medium, and deep yellow or fire red, deep red, and magenta.

If you are not yet comfortable with color mixing, experiment with a set of acrylic or watercolor paints first: Mix two colors, examine the result, and continue with more colors to reach the shade you want. You need only small amounts of each color to alter the mixture. Then add white to see the result, and then black. For reference, keep a record of the formulas and what makes colors bright or dull.

Opaque color provides solid coverage, preventing the paper or color underneath from showing through. White and black screenprinting inks usually are opaque. Reds, oranges, and yellows often are more transparent than darker colors.

Translucent refers to a color that is not opaque and not transparent, one that allows some of the underneath color to be visible.

Transparent color tints the underlying color to create a third, just as colored cellophane affects the colors of objects behind it. To make a color transparent, gradually add opaque ink or toner to transparent base until you reach the desired shade. Adding base to the pigment instead would leave you with a greater amount of the mixture than you will need. Make a small square stencil on the screen to print color samples.

Alabaster Eden, Lynwood Kreneck, 14½" x 10½"

Kreneck printed using Lyntex inks by Createx and Speedball. Eleanor Kreneck photographed this print.

Opaque **Translucent**

Transparent

Mixing Lights and Darks

Adding white to a color will lighten it, make it more opaque, and lessen its intensity. Adding other light colors will lighten darker ones without dulling them as much. Try mixing yellow into dark green. Similarly, add a dark color, such as dark blue, to a lighter color like green, instead of adding black, which dampens the intensity.

Maintaining Color Vitality

You also can intensify color by printing a complementary color next to it. Try printing red next to green or orange next to blue. Colors of the same value, or scale of lightness/darkness, also create interest.

Start with four opaque colors, then make them transparent and print them over each other. Cut out the swatches, recording the layers that produced it.

Lightening a Color

Do not deaden a color with white. To lighten it, use transparent base or a lighter color instead, as I did to lighten the original color at left.

Darkening a Color

Do not deaden a color with black, as done at near left. Use blue or another dark color to darken it, as done at far left.

Ink Additives

Metallic Effects

Add metallic powder to transparent base to produce metallic colors, and wear a mask to avoid inhaling it. Silver and gold screenprinting inks are available, but they show up better printed over a dark color, which keeps the metallics more intense because the ink is not absorbed into the paper.

Retarders

Add retarders to a color or mixture to help the ink flow through the mesh and to slow evaporation, thus preventing the ink from drying in the screen; removing water-based ink from the screen once it has dried is difficult. Look for retarders from the ink manufacturers or from acrylic paint manufacturers like Golden. Propylene glycol, an ingredient in most retarders, also works very well.

 I knew a printer who would print four layers of base onto the paper before starting an edition. He claimed it kept all the ink on the surface. My opinion is that it kills some of the intensity of color that exists when you allow the paper to absorb the base. Experiment with both techniques to see what suits you.

Bouncing Colors

When placed next to each other, one color can intensify another.

Holy Grail, Robert Schwieger, 63" x 10½" x 10½"

Schwieger printed with water-based acrylic inks on various substrates.
This print is in the collection of the artist.

Matching and Proofing Colors

Select the swatch from the ink manufacturer's samples that is closest to the color you want to match. Check the intensity, or brightness. Is the swatch lighter but still brighter than the artwork's original color, or is it lighter and duller? Mix a small amount of ink using your comparison for adjustment, record the formula for reference, and print a proof.

Proof sample color swatches of your ink mixtures before printing them onto your finished piece and check to see that they dry to the colors you want; some colors dry lighter and some darker. To proof a color, print a small blob of ink through the stencil or through a separate small screen that has a two-inch square opening. Proof your colors on the same kind of paper onto which you will print your edition.

Most professional shops devote a staff member to mixing inks and a separate screen for printing proof swatches. If you are trying to match colors to an original artwork, dry the color swatch with a hair dryer, cut it out with scissors or a mat knife, and compare it to the original. Make sure to cut away all the white paper from the swatch so it will not interfere with the swatch's true color.

Once you have mixed and matched a color for each color separation, proof all the separations together to see that the colors mix/layer as you want them to and that you have made the separations correctly. This process also help you check that the separations fit, with no white paper showing where it should not.

#618 Tradecraft Concealments VI, Allison Smith, 8¼" x 3" x 3"

The color separations were made using Rubylith film, photocopies, handpainting, and ChartPak tape. A screen was made for each color and printed with TW Graphics inks. It was printed at the Lower East Side Printshop. Smith cut out and scored each print and assembled it into a box.

Blending Colors

You can blend colors directly on the screen in addition to achieving continuous tone through photographic stencils and handdrawn stencils. This method will not produce consistent prints, as the blended area varies with every print.

To produce a color blend on the screen, choose a mesh for your screen according to the kind of ink deposit you need to achieve for your blend: For a heavier, more opaque deposit, use coarser mesh, 180- to 200-monofilament. For lighter, more transparent deposits, use 230- to 260-monofilament mesh.

Create an open area on the screen using a stencil, place the screen on your printing table, and prepare the colors you want to blend outside this open area. To blend blue and pink, pour blue along and in front of the squeegee, from the bottom halfway up the screen, and pink from the top halfway down so they meet in the middle. Push the two colors back and forth until they start to blend using a piece of cardboard. Then continue blending with a squeegee.

Test the blend by placing a sheet of newsprint scrap paper under the screen and printing it with the blended ink, pushing the color across the screen with the squeegee. Do not pull the squeegee from one color to the other at this point. Print the blend, reflood the screen, and repeat until it prints evenly. Then print your final piece.

A blend can only be printed the direction that the squeegee is pulled. If printing from side to side, the blend will go top to bottom. If printing from top to bottom, the blend will go from side to side.

When the blend begins to differ too much from your original, after maybe eight to ten printings, start over with fresh ink. One color might start to overpower the other, especially if the colors' viscosities, or consistencies, differ. The slant of the screen, due to the slant of your table or the pressure from the squeegee, also might help one color begin to dominate.

Cleaning Up Blended Ink

Instead of returning the ink to its original containers for re-use, as you typically can do, scoop the blended color from each screen into its own container to use for color mixing and matching for another print. Then wash the ink out of the screen with a sponge and water or a spray hose in a sink.

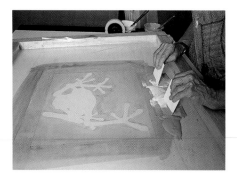

Start the Blend

Push the colors back and forth using a piece of cardboard.

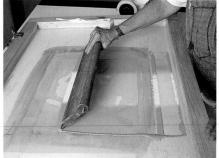

Flood the Screen

Push a squeegee across the screen.

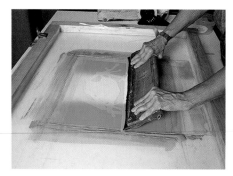

Print the Screen

Pull the squeegee forward using fairly even pressure. Print the image on newsprint paper several times until the blend prints smoothly.

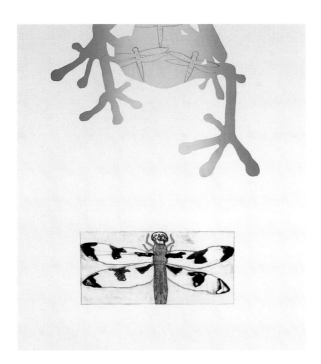

The Finished Print

I printed this frog with one screen, blending the two colors with a squeegee as it printed the image. Then I drew on the screen with graphite and printed it separately. The dragonfly on the bottom was a monoprint.

A Displaced Game of Cat and Mouse, Bruce Pearson, 18" x 24"

This thirteen-color screenprint with a background color blend were made by hand from an original gouache painting. James Miller printed the image with TW Graphics ink on Magnani Incisione paper at the Lower East Side Printshop.

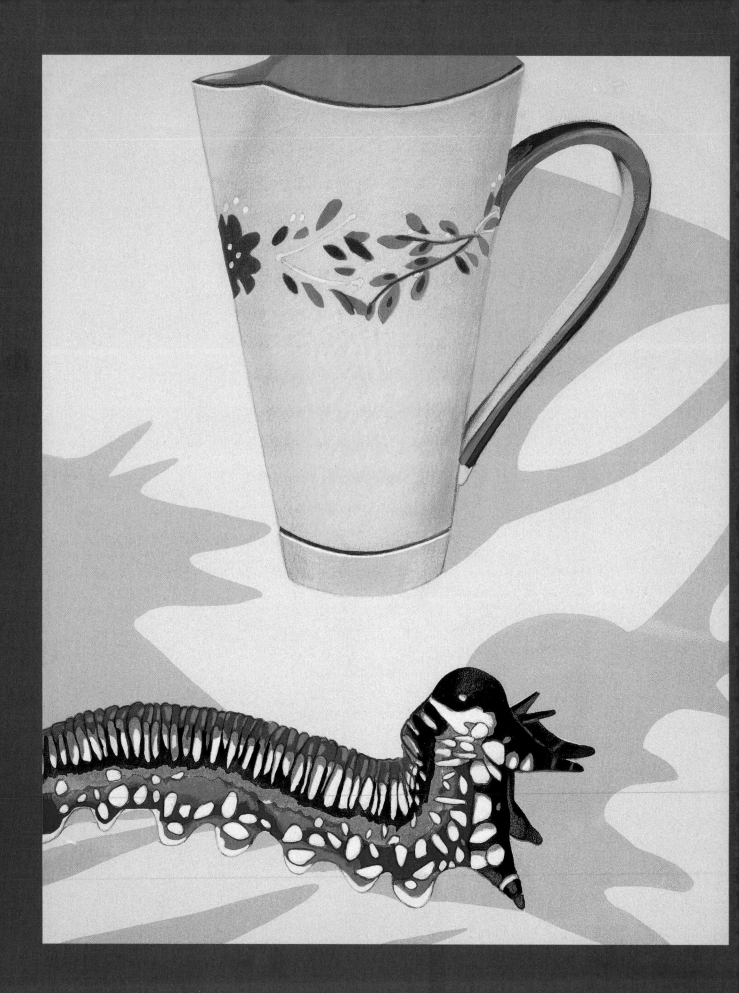

6

Printing Screenprints

There is nothing like the brilliant bold color that can be printed with a screen. Screenprinting, which developed from stencil printing, has proved to be versatile and user-friendly for artist and craftsperson alike; simple to understand and easy to master, whether in a large professional shop or a small art studio. Especially when using water-based inks, anyone can print without worrying about toxic chemicals in his or her home studio.

Screenprinting is used commercially and for fine art editions and artists can also use it as a tool for combining and enhancing artistic projects. One can get started with just a screen, a squeegee, a table and some ink. Proceed from there to develop more complex and interesting techniques like monotypes; combining other mediums like lithography, etching, and woodblocks; and printing on fabric.

Right This Way, Roni Henning, 30" x 22"

This eight-color-separation print used half-reduction and half-handmade stencils that were made with black ink on textured acetate. I printed on white Somerset paper with standard water-based inks at Henning Screenprint Workshop.

Screenprinting Tables

You can work on any flat surface as long as you can secure one side of the screen to it. You must be able to raise and lower the screen from the front. You also can buy or make a printing table. Professional tables come with a vacuum compartment that holds the paper in place when the screen is down and automatically releases the paper when the screen is raised. Others tables have manually-operated vacuums.

The printing tables are usually metal with an attached bar into which the squeegee fits, called a one-arm squeegee. This assembly glides perpendicular to the back of the table, and the screen is attached by a horizontal clamp to the table. The counterbalance system allows the screen to rise and lower easily. The one-arm squeegee enables you to print larger images by balancing the pressure.

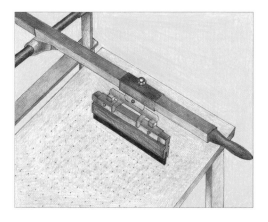

One-Arm Squeegee

A bar with a handle holds the squeegee. The horizontal clamp that holds the screen is not pictured here.

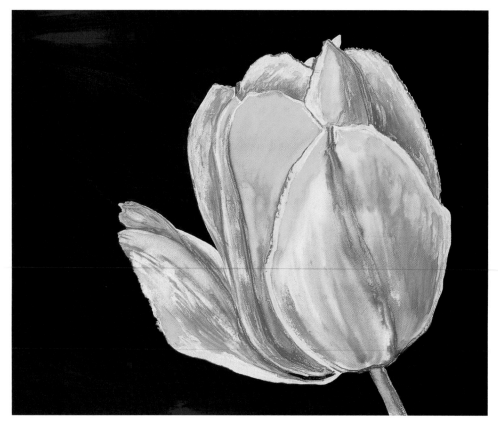

Tulip, James DeWoody

DeWoody made this screened mono-type and then blocked out the tulip with screen filler and printing the background color with screen inks.

Handmaking a Table

Glue a piece of Formica, cut to size, to a table so you have a smooth work surface. You can clean the Formica easily with soap and water. At an art or printing supply store, purchase a set of hinge clamps, and screw them to the back of the table.

Make a vacuum compartment under the table by drilling enough holes, one-inch apart, to create enough suction surface to hold a piece of paper down on the Formica. Build a shallow wooden compartment under the tabletop. Cut an opening into the compartment for a vacuum cleaner hose, and create an airtight seal around the hose using glue and duct tape.

For smaller prints for which you can make do without a vacuum, you also can make a simple surface of a smooth, ¾-inch piece of smooth plywood and then attach hinge clamps.

Nearby, place another table—ideally on wheels so you can move it when you are not printing—so you have easy access to the papers onto which you are printing.

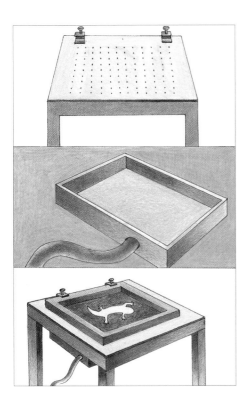

Making a Printing Table

Drill holes into the top of the table, over the vacuum compartment, and cut one on the side for a vacuum cleaner hose. Secure hinge clamps to the table to fit a screen, flat side down, into them.

Drying Table

Make or purchase a table with casters to hold the papers onto which you will be printing.

Hinge Clamps

Attach hinge clamps to the back of your table to hold the screen.

Drying Racks

Place each printed sheet of paper on a shelf or rack to dry. Professional drying racks have fifty crisscrossed wire shelves that allow air to circulate around the prints for quicker drying.

You also can develop your own drying system. One artist I know attached casters to a wooden base and then two 2- x 4-inch boards vertically as the main supports. Then she nailed wooden slats about six inches apart to the boards and inserted corrugated cardboard "shelves" into the slats.

You also can make individual, stackable shelf frames out of 1- x 2-inch pieces of wood and use chicken wire for shelves. Staple or nail each piece of wire to each frame. Place a printed sheet on a shelf, then stack the next shelf in preparation for the next print. You also can use clothespins to hang prints on clotheslines to dry.

Work Efficiently

Elsie Manville's prints are drying on a professional drying rack.

Squeegees

You will print the ink with a squeegee, which is made of a wooden handle and a polyurethane or rubber blade. When you push or pull a squeegee across a screen, it forces the ink through the open mesh onto the paper. Squeegees come in different sizes, compositions, styles, and durometers. The edges of rubber blades, usually student grade and cheapest, wear down quickly. Solvent-based inks even dissolve them slightly. Most printers use polyurethane blades.

Durometer refers to stiffness. A softer, sixty-durometer blade is flexible and easier to push but often prints too much ink. A harder, eighty-durometer blade prints a thinner deposit, good for halftones and details. Start with a medium, seventy-durometer blade, especially if you are working with a one-arm squeegee, which provides even pressure so you do not need the aid of a lesser-durometer blade's flexibility. Then experiment to find the blade that works best with the amount of pressure that comes naturally to you.

A flat blade with two sharp edges is the most common shaped blade for printing on paper. When the edges become rounded, the squeegee will print thicker, less sharp color. You can restore the sharp edge by stapling very fine sandpaper to a wooden board, which provides stability, and rubbing the squeegee back and forth across the sandpaper. Then smooth the blade with steel wool until the squeegee prints without producing streaks in the color.

One-Arm Squeegee

A one-arm squeegee has balance weights to make printing large-scale prints easier. The amount of pressure you apply distributes evenly. You can adjust the arm to print down wherever you need more pressure. You also can change the slant using the screws on the metal base.

Two Kinds of Squeegees

Use a small squeegee, like the one with a yellow blade, for handprinting. The larger one with a groove fits into a one-arm squeegee bar.

Real Feelings Giftwrap Series: That Wasn't the Real Me, Peggy Diggs, 36" x 24"

Diggs created the drawings for this screenprint on gift wrap paper using Adobe Illustrator software. The images were output on acetate sheets. Marc Lepson and Dusica Kirjakovic printed it in seven colors with TW Graphics ink at the Lower East Side Printshop.

Paper

The paper-making process can produce rough paper with texture or smooth paper, hard or soft paper, and coated or porous paper. Water-based inks print differently on each kind. A smooth, hard surface prints halftones and details well, and monotypes print well on such a surface. Porous, rough, and grainy paper adds texture when you print handdrawn crayon stencils. The artist of the original work should determine what paper will work best with his or her imagery.

Choose heavier paper, which is more stable, if you are working on large sheets. Paper also comes sized or unsized. Sizing is a gelatinous substance added during the paper making process. Unsized paper, called waterleaf, is absorbent, causing ink to spread or blur. Instead, use sized paper, which is more stable and absorbs only a small amount of ink preventing the moisture from water-based inks from affecting the paper.

Like all printmakers, I have my favorite papers: Arches, Rives BFK, Somerset, and Coventry. Arches Cover paper can stand up to erasing and even shaving with a razor blade should you need to remove an unwanted spot from the white paper, especially on the border.

Handle paper carefully. Grip it with two hands when moving it from one surface to another, keeping it slightly curved to prevent crimping, the dimpled impression created when you bend paper as you pick it up.

Paper's basic component is cellulose fiber from wood, cotton, bark, or certain plants. The fibers are beaten or separated, then mixed with water to form a pulp. Paper made from wood contains acid, which can cause the paper to discolor and deteriorate. Print fine art editions on 100 percent cotton-rag, acid-free (pH neutral) paper, which is made from renewable resources.

Remember that fine art is about not only editioning but also creativity. I have seen images printed on craft paper, newspaper, and rice paper, all with excellent results.

There are handmade, molded, and machine-made papers.

Handmade Paper

A cotton-rag paper maker agitates the pulp in a vat of water to break up the fibers. A frame covered with fine wire mesh is called a mold. A deckle, another frame, fits over the mold. The maker dips the mold and then the deckle into the vat and puts them together, swivels the assembly to a flat position to capture the mixture, and lifts it out. As the water drains, some fibers slip under the deckle, hence the deckle edge of handmade paper.

The maker then deposits, or couches, the sheet of wet pulp on a felt blanket and covers it with another blanket, eventually assembling a stack, which the maker than inserts into a press to squeeze out the excess water. The more times he or she presses the pile, the smoother the paper gets. Then the maker separates the sheets from the felt blankets and dries them.

#618 Tradecraft Concealments IV,
Allison Smith

The separations were made by hand using Rubylith film, photocopies, handpainting, and ChartPak tape. They were printed with TW Graphics ink onto Strathmore Bristol series 500 plate finish white paper. Smith then cut out and scored each print to be assembled into a box. The print is published by the Lower East Side Printshop.

Molded Paper

Most printmakers choose molded paper, made from a cylinder mold machine, for its consistent texture and the grain's definite direction. The pulp attaches to the cylinder, covered in fine steel mesh, as the cylinder rotates. While partially submerged in a vat of water and pulp, the paper is couched onto a felt blanket and then onto rollers and has two deckle edges.

Machine-Made Paper

A Fourdrinier machine, named after its inventors, makes machine-made paper. The pulp is stored in a vat above a moving wire mesh belt. The pulp is sprayed onto the belt, the water drains away, and the paper is couched off the belt and wound onto reels and steam-heated cylinders. The machine dries it and prepares it to be cut into sheets. The machine creates no deckle edges.

The machine makes hot-pressed paper, which has a smooth surface, by passing it through hot metal plates on rollers. It makes cold-pressed paper, which has a medium texture, by running it through cold metal rollers. Rough paper, with the grainiest texture, is dried without re-pressing.

Legacy, Juan Sanchez, 22" x 30"

This water-based screenprint with photocopy and collage was printed by Dusica Kirjakovic and Courtney Healey at the Lower East Side Printshop on black Stonehenge paper. The print is provided courtesy of Sanchez, the Lower East Side Printshop, and Dieu Donne Papermill.

Substrates

Commercially, screenprinting always has been used to print on other materials in addition to paper. You need only look around at the bottles and containers in your home to see examples. When printing on thick materials like wood or Plexiglas, you have to consider your setup. The outside perimeter, the sides, of the object onto which you are printing must be the same height so the squeegee can slide smoothly across the surface. Also, when printing onto wood, you can incorporate the wood grain into your art or sand the wood smooth.

One Image, Four Surfaces

I printed this image over fabric (*top left*), rice paper (*top right*), 300-lb. cold-pressed paper (*bottom left*) and purple tissue paper (*bottom right*).

Blue Bucket 2, Jacqueline Maggi

This screenprint was printed on birch veneer and the surface was reworked with sharp tools and razor blades used to cut back through the ink to reveal the wood. Red tinted wax was rubbed into the surface. It was printed by Dennis O'Neil at Hand Print Workshop International.

Fabric

The textile industry has used water-based inks and water-soluble dyes for years. The inks' consistency penetrates the fabric easily. Some ink must be heat-sealed to make it permanent. You can also do so by ironing the inside, unprinted side, of the fabric.

Generally, water-based textile inks do not print that well on paper. The smaller amount of pigment does not produce enough intensity, and the higher water content can buckle the paper. But artists do use both textile and poster inks to print on fabric or canvas to add another dimension to their art. The fabric stretches, so use spray mount adhesive to aid in keeping the material in place if you do not have a vacuum. You may need to mount extremely porous fabric on cardboard for printing.

For a simple way to print a T-shirt, cut a piece of cardboard to the size of the shirt. Spray it with spray mount adhesive, and then slip it into the shirt. Fold the sides and bottom of the shirt and tape them in place in the back. It will be bulky. Place the assembly under the screen in register to the image. Securely tape cardboard that is the same height as the shirt around the shirt on the bottom and left and right sides. Make sure the cardboard is the same height as the shirt and is touching it to hold it in place for registration. Professional T-shirt printers use a different setup and equipment. This method is for the artist who wants to print only a few shirts.

Fabric Designs

Robert Paige designed the fabrics above. They were printed with water-soluble dyes.

Heir / Air / Loom, Hand to Mouth, Wennie Huang, 18" x 18" x 18"

This print is made of photos of Huang's grandparents that were manipulated using Adobe Photoshop software. The images were printed onto paper and enlarged to actual size on vellum. They were printed onto separate pieces of silk with TW Graphics black water-based ink. Huang sewed the printed silk together and fabricated individual box kites. Marc Lepson and Courtney Healey printed them at the Lower East Side Printshop. The print is provided courtesy of Huang and the Lower East Side Printshop.

Registering Paper

Registration ensures that color will print in the exact same place on each sheet of paper, by making sure each sheet sits under the exact same part of the screen.

Place the screen on the table, flat side down, and push the screen into the hinge clamps. Tighten the clamps to hold the screen securely so it does not move from side to side. Tape the color separation from which you made the stencil onto the paper where you want to print it. Then move the paper under the screen until the separation lines up with the open mesh. It helps to tape a ruler onto the paper to create a handle for moving the paper while the screen is flat. When the paper is in position, tape it in place on the table.

Registration Cards

Cut three 1- x 1½-inch pieces of cardboard or illustration board, making sure the edges are sharp and straight. Place one piece flush against the right side of the paper about one inch up from the bottom corner. Place the other two flush along the bottom of the paper, one near the right corner and one near the left corner. Use masking tape to tape the cards down so the paper will not slip under the cardboard.

Punch-Hole Registration

Punch two holes on the left side of the paper, one near the top corner and one near the bottom corner. Mark these holes on the table. Look in art and printing supply stores for metal tabs with vertical pins that fit the holes exactly. Tape the tabs down on the table so they will fit in the holes punched in the paper. You also can look for bars with vertical pins. These tabs must lie outside the screen's frame. This method works well when you want to preserve a deckled edge. You will have to punch each piece of paper, so do not use this method for large editions.

Spot Registration

When your colors are not printing in the exact same place on each sheet—noticeable especially once you start printing multiple colors—tape the entire left side of a piece of clear acetate over the entire paper, securing it beyond the screen frame's edge. Print the stencil onto the acetate and dry it with a hair dryer. Reposition your paper, on which the first color is in register, so it registers correctly under the acetate's second color. Flip the acetate out of the way, lower the screen, and print the second color on the paper. Remove the printed paper and flip the acetate back into place under the screen. Continue printing that way.

Registering Your Paper

Cut three pieces of cardboard or illustration board and tape two flush along the bottom and one along the right side of the paper, as at top. Or, punch holes in your papers and adhere a bar with pins that fit into the holes to your table.

Spot Registration

To make sure the second color aligns with the first printed color, tape a piece of clear acetate onto the paper, print the second color onto the acetate, and align the surface onto which you are printing with the printed acetate. Then flip the acetate out of the way and print the second color onto the surface.

Checking the Screen Contact

Make sure the screen is "off-contact" enough. The mesh should not touch the table when the screen is in the down position. If the screen is stretched tightly enough, the hinge clamps will lift it enough. When the squeegee pulls the ink across the screen, the mesh should snap off the printed paper consistently so the ink prints evenly, especially necessary when you are printing large blocks of color. If the mesh releases too slowly, it will leave a rainbow shape in the color. If, however, the screen is too much higher off the table, the color will not print everywhere you want it to appear. To increase the off-contact if necessary, place cardboard or rolled paper towels under the frame on the two front sides of the screen.

The Ladies' Mixmaster, Kathryn Maxwell, 14" x 11"

Maxwell printed the photo and hand separations for this print with water-based inks.

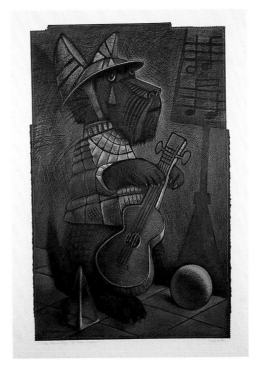

Little Clown Dog / The Music Lesson, Lynwood Kreneck, 37½" x 25½"

These screenprint monoprint was made by drawing and sewing. Eleanor Kreneck photographed the print.

Just Right

If the screen is stretched tightly, the mesh will not touch the table. The squeegee will force it into contact with the paper as you print, and the screen will snap right back up so as not to leave any unwanted marks on the print.

Proofing and Printing the Edition

Proof an edition before printing it to test the stencils, screens, and inks by printing about 25 sheets. If the separations are not correct and the stencils do not fit, re-create them and make new screens.

You also will mix the colors and test them through the screens during the proofing process. You can make a set of progressive proofs at this time to record how the print is made. This helps determine how to correct a stencil.

Print the first color on 25 sheets. Put one sheet aside and print the second color on 24 sheets. Put one of these aside and print the third color on the remaining 23 sheets, and so on. Continue until you have printed all the colors.

When printing, you need to work efficiently to make the process run smoothly. Gather your printing materials so they are handy. Keep the edition paper on a nearby table for easy access. Have paper towels and a spray bottle filled with water ready in case the ink dries in the screen while you are printing, which happens only when you take too long between each printing and you have not mixed enough retarder into the ink.

When printing large prints, you might want to place a platform in front of the printing table to give you more height to lean over the squeegee as you push it.

State #1

One color

State #2

Two colors

States #3, 4, and 5

Three more colors

State #6

One more color

State #7

One more color

State #8, 9, 10 and 11

Four more colors

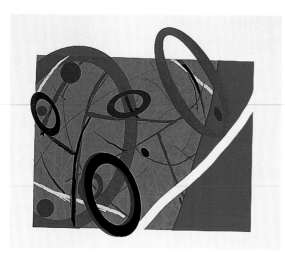

Counterpose Series/ #3, **Richard Hellman**

Hellman made the color separations with Adobe Photoshop software and printed them. The print is provided courtesy of Montage Gallery, Baltimore, Md.

One-Arm Squeegee System

To connect a screen to the one-arm squeegee, push the screen into the metal clamp at the back of the table and secure it. Attach the chains from the back of the assembly to the two clamps attached to the frame on either side near the front. Hold the screen up when attaching the chains. The screen then should remain up when you let go. If moving it down is not easy, though, adjust the weights in the back.

When the screen is in the up position, it should look balanced, you should be able to see under it, and you should have enough room under it to register paper and remove prints. On the other hand, if it is hanging too high, the ink will constantly flow to the back of the table because of the angle.

Turn on the vacuum. If the suction does not hold the paper, cover the holes that are exposed with tape or newsprint paper. Turn the vacuum off, then flood the screen with ink in preparation for printing. To do this, lift the screen up. Pour ink on the screen between the squeegee and the open mesh of the stencil so the puddle runs from one end of the screen to the other. Holding the handle of the one-arm squeegee with a firm grip and at a 45-degree angle, slanted toward the stencil, pull the ink across the surface so it fills the open mesh. The color should saturate only this area evenly.

Turn the vacuum back on, and put the screen down. Maintaining a 45-degree angle, push the squeegee over the ink-covered screen in the opposite direction from the one in which you flooded the screen. As the squeegee pushes across the stencil, you should see the screen release from the paper behind the squeegee. If not, the off contact is not high enough or the screen is not stretched tightly enough.

Immediately lift the screen and flood it again to prevent the ink from drying. Check the quality of the printed color. Look for streaks in the color from poor mixing and for rainbow marks. If the color looks good, keep printing.

Always use proof paper—newsprint paper—to print the first few prints. When the color is printing correctly, switch to the edition paper.

Handprinting

If you do not have a one-arm squeegee and vacuum table, hold the screen in the up position with a block of wood when flooding the screen. Secure the paper to the table with a piece of masking tape on either side only if it moves when you are printing. This can happen if the area you are printing and the ink holds the paper to the screen and does not release it. You also can use spray mount adhesive on the table to hold the paper. Flood the screen from the front to the back with a squeegee held at a 45-degree angle and print using medium pressure from the back to the front.

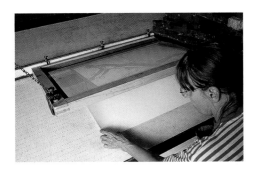

Position the Paper

Place the paper in register under the screen.

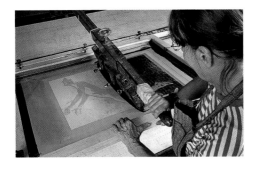

Flood the Screen

Pull the ink across the screen to flood the image.

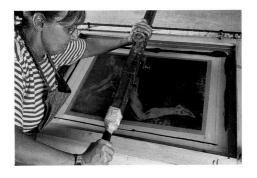

Printing the Image

You can see ink push through the screen as it prints.

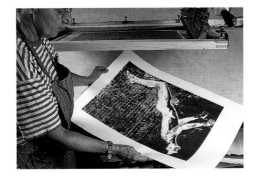

Check the Print

Check the halftone for correct printing.

Putting the Process Together

Artist Kevin Ryan and I collaborated on this screenprint and monotype. I printed a halftone first, then blocked out an open area on the screen. Ryan then used watercolor to paint a monotype in the open area of this second screen. I printed his painted monotype over the halftone print.

Halftone Screenprinted

The halftone film on the light table corresponds to the screen on the printing table.

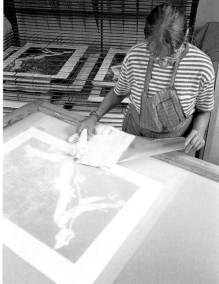

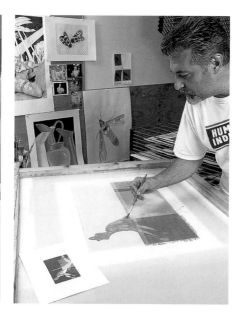

Prepare the Monotype Screen

I am placing contact paper on the open areas of the next screen to block the ink.

Paint a Monotype

Kevin Ryan is painting the screen with water-color for the monotype.

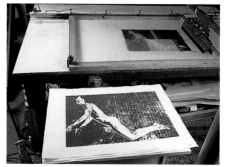

The Painted Screen

The painted screen is on the table waiting to be printed on the halftone prints, which are next to the table for easy access.

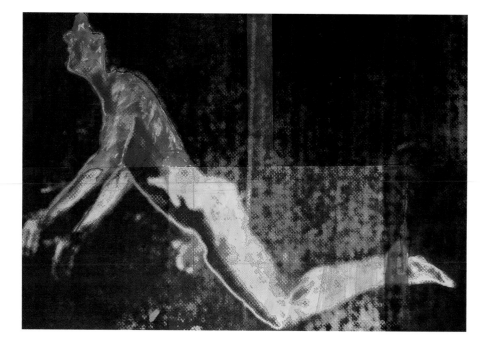

Untitled, Kevin Ryan

I printed this halftone print and a monotype, painted by Kevin Ryan in watercolor, over it.

Printing Tips

- Approach printing precisely and methodically. Pay attention to all the details. Have all the supplies in a convenient location (filled water bottles, paper towels, and tape so you can make quick corrections while printing, such as blocking a leak in the stencil with tape before the ink seeping through has dried.

- Keep everything clean. Avoid dripping ink on the side of the can, which then can transfer to the table and your hands. Many a print has been ruined with ink fingerprints.

- Some water-based inks start to build up on the inside of the screen after about fifty prints, unlike oil-based inks, which have a slippery quality as they print. If this happens, scoop the ink out of the screen, return it to the container, thin it with retarder, and mix it thoroughly before returning it to the screen. This will minimize buildup and keep the viscosity consistent. I also spray water very lightly on the sides of stencils as I print to minimize buildup, but make sure the water does not get into the open mesh or it will change the color that you are printing.

- If you have created multiple stencils on one screen, print them one at a time, blocking out the others with wide cellophane tape or contact paper on the inside of the screen. Blocking from the underside of the screen, as you would with oil-based inks, would allow the ink from the first printing to dry in the stencil. The emulsion stencil also remains cold during printing and is resistant to tape from underneath.

- Make sure the mesh remains open when you print textures or fine details, such as halftones. Watch the screen as the squeegee moves across the image. If the ink is drying in the screen, it will appear distinctly darker at the edges of the dry ink spots, and ink will not print there. It will look like less and less is printing on the paper.

- Watch the screen for changes in color. If the ink looks glossy, it didn't print; if the ink has gone through the screen as it should, the mesh itself will look dry. If the ink is drying too quickly, add retarder, spray water on a paper towel, and wash the dried areas before reflooding. Then reflood the screen and print on proof paper until it again prints correctly.

- If too much detail is printing, wipe the underside of the screen with a dry paper towel, then reflood the screen. Just print the screen without bringing the excess ink across. Do not flood to bring all the ink across when you print the next time. Go back and forth like this to keep the detail exact. You can flood in either direction, but always print in the same direction so as not to affect the registration.

- Make sure the squeegee blade has no hills or valleys. Be sure the registration guides are not so large, close to the printing area, or much thicker than the paper as to interfere with the squeegee.

- Print toward the registration guides. If the screen moves as you print, put a C clamp against the end of the frame of the screen toward which you push the squeegee.

- The squeegee should have easy clearance within the frame but overlap the open mesh by two or three inches on either side.

Troubleshooting

- If ink is coming through in unwanted areas, the stencil has broken down. If a few pinholes did not get blocked out, cover them on the underside of the screen with sticky cellophane tape. If the stencil seems weak, it did not harden enough during exposure. Remake and harden the screen longer.
- If too much time elapsed between printing or you did not mix enough retarder into the ink, the ink may dry at the edges of the stencil. Scoop the ink out of the screen, return it to its container, add retarder, wash the screen with water to open the dried edges, dry the screen with a hair dryer, and reflood it.
- If ink prints under the stencil and blurs on the edges, evaluate your squeegee stroke. Flipping the squeegee up at the end of the stroke can push ink under the stencil. Keep the squeegee at a 45-degree angle. The ink also could be too thin. Remix.
- Uneven pressure on the squeegee will print uneven color. Press down equally on all parts of the stencil. Also make sure you mixed the color thoroughly.
- Poor mixing also can create streaks. Remove the color from the screen and mix it thoroughly. If dots of color appear again, strain the ink by using an ink spatula to force it through finer mesh into a clean container. If the squeegee is causing streaks, remove it from the screen and wash off the ink. If the edge feels rough, rub fine steel wool over the edge to smooth it.
- If a photographic halftone fills in and does not print cleanly, make sure the screen is off-contact: Try flooding the screen, but do not bring the ink across when you print. On the next printing do not flood the screen and then print with the ink you did not bring across with the first printing. Continue printing this way, flooding every other print. Also try flooding less ink, use a paper towel to wipe the stencil under the screen after every other printing, or print on smoother paper. Print on newsprint to clean the ink up.
- If the ink is tacky, you may have added too much retarder; retarder should make up only 10 to 15 percent of an ink mixture.
- If the colors are not aligning, tighten the clamps to hold the screen still, check the registration guides, butt each sheet of paper up to the guides, and make sure the paper is not slipping under or over the registration cards.
- If the mesh does not release from the paper quickly enough after printing, rainbow shapes may appear. Make sure the screen is stretched tightly enough and sits high enough above the paper in the off-contact position.

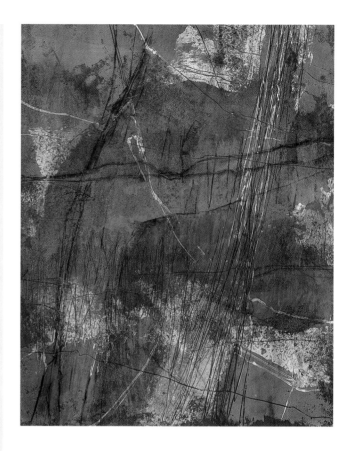

Untitled, Dan Welden

The screen was turned over on the table and Welden made a rubbing of an etching plate with water-soluble crayons. It was reworked and printed. A solar plate etching was printed over it.

Using Print Mediums Together

Screenprinting is very versatile and it is easily combined with other print mediums. When combining etching and screenprinting, print the screenprinting inks first, before the etching plate can distort the paper and thus affect the planned registration for the screenprint. Print monotypes after etching so the damp paper or the etching does not affect your gouache or watercolor applications. Lithography and wood block printing can be combined with screenprinting in any order because there are no plate marks, although the litho inks can sometimes be resistant to the water-based inks.

FPopen, **Lise Drost**

Drost printed this combination of litho and screen. The print is in the collection of the artist.

Cleaning the Screen

I dreaded cleaning the screen with solvents when I used to print with oil-based inks; I hated leaning over the screen wearing a mask and yet still smelling the fumes. Cleaning up water-based ink is a relative pleasure.

After you have printed the last sheet, do not reflood the screen, place newspaper under the screen and spray the open mesh with water. Remove the excess ink from the screen and squeegee blade using an ink spatula or piece of cardboard, and return it to its container. I also set aside a tiny amount of each color for touch up during my inspection of the finished edition.

To clean a screen on your printing table, which conserves water and keeps the screen in register if you are making reduction prints, it is good to wear gloves, such as thin surgical gloves; even water-based inks are not totally nontoxic. Wash the screen with a sponge and spray water bottle. Continue to wash both sides of the screen until the ink is gone. Dry it with paper towels. Change the newspaper whenever ink saturates it. The color may leave a stain in the screen.

To use a washout stand or large sink, use a hose to thoroughly wash the ink off both sides of the screen, then dry the screen in front of a floor fan (*see page 82*).

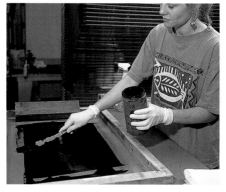

Scrape the Screen

Scrape the ink out of the screen and put into a container.

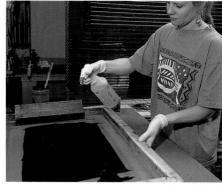

Spray the Screen

Place newspaper under the screen and spray the ink with water.

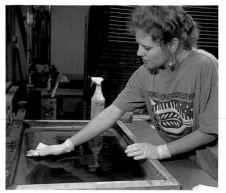

Wash the Screen

Wearing gloves, wash the ink out of the screen using water and paper towels.

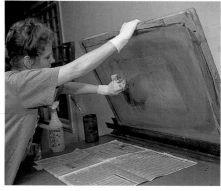

Wash the Other Side

Wash the other side of the screen to remove all the ink.

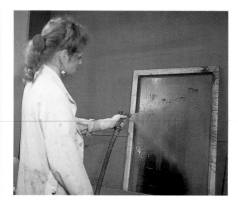

Or Use a Washout Stand

Place the screen in a washout stand and wash the ink away with a hose.

Removing Emulsion and Finishing Up

Wearing gloves, place the dry screen in a washout stand. Use a wide paintbrush to liberally apply stripper, emulsion remover, or bleach to both sides of the screen. The emulsion will start to dissolve after a few minutes; bleach will take a bit longer. When you see it start to loosen, wash it with warm water. If it does not come off easily, apply more stripper and wait a few more minutes.

While waiting for the stripper or bleach to begin working, keep checking that the screen is still wet; if it were to dry in the screen, it would bond chemically and be harder to remove. Test it by spraying one corner with water to see if the emulsion is washing away. If not, again apply more stripper on it and let it sit longer.

A ghost image of the color that you just printed will remain in the screen. Scrub off any other stubborn spots using an abrasive cleanser and a stiff nylon brush. If you used bleach to strip the screen, neutralize it by applying acetic acid (white vinegar) to both sides with a sponge and washing the screen with water one more time. Now you can use the screen for another stencil.

You can get stripper from most suppliers of emulsion or screen supplies. Nazdar makes a good stripper. Professional print shops also have high-pressure washers connected to their water systems to remove emulsion.

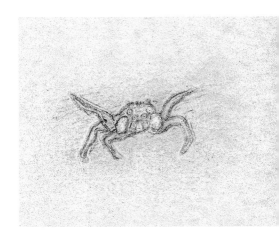

Henning Screenprint Workshop Chop Mark

I use a jumping spider as my chop mark.

Collating Prints

Inspect the completed edition for flaws, and separate the flawed prints to see if you can correct them. Scrape dots of ink from the borders using a razor blade. Erase fingerprints and dust. Discard any misregistrations.

You should have decided how many prints would make up the edition before you started printing. Destroy extras to preserve the value of the prints.

Have the artist sign and number the print edition with pencil, which identifies it as an original print. Otherwise, printers could replicate unauthorized signatures by printing ink.

Emboss your identifying mark, called a chop mark, into the left bottom corner of each print. The chop mark of Henning Screenprint Workshop is a jumping spider.

Safety Tips

Even your water-based inks may still contain some toxic elements, so follow the manufacturers' warnings and instructions. The manufacturers can supply Materials Safety Data Sheets for their inks. Remember to wear gloves when you are cleaning ink out of the screen or stripping the emulsion. As an artist and printmaker, my only concern with supplies used to be in relation to the result I wanted. There was a time when I would experiment with any materials with a total disregard of my own health. Today, I rarely use anything with such abandon.

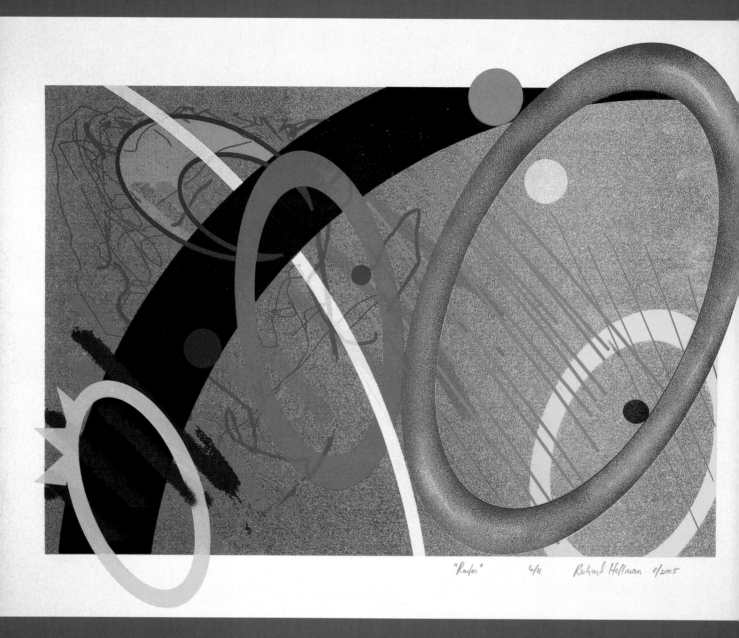

Rodeo, Richard Hellman, 15" x 22"

Hellman completed this edition of eleven 18-color screenprints in July, 2005. He printed on two-ply archival museum board using Hunt Speedball and Createx acrylic inks and mediums, Golden's Flow Release, and slow-drying acrylic glaze medium. He used screens of 230, 305, and 195 thread count depending on the detail and ink deposit required. He printed different stencils on FastPos Film, Casey's Translucency, and Lexan using a Canon Pixima iP 4000 inkjet printer, an HP Laserjet, and a 24-inch wide HP Deskjet.

7

Computer Techniques

Using the computer in screenprinting combines the skills of the artist-printmaker, graphic designer, digital photographer, and pre-press craftsman. Today's artist may elect to create digital prints solely or to over-print digital prints with traditional printmaking methods. In this chapter, you will learn about the equipment, mark making, manipulating an image, and creating photographic stencils that you can transfer onto screens. To print predictable continuous-tone images, you will have to convert them into high-contrast, opaque black marks. The end-result will be a handpulled original screenprint.

This chapter, written by Richard Hellman, does not intend to be the definitive method for using computers in screenprinting. Many artists and printmakers have worked out their own systems. Instead, it is a jumping off point. These methods are the result of Hellman's research and experimentation with using the computer as an extension of the artist's hand, like a brush, roller, scraper, or other tool for mark making; manipulating images; and his methods for creating stencils.

Hellman remarks, "With the technical innovation of sophisticated graphics programs and archival inkjet printers, the line between original prints and reproductions has gotten thinner. As a printmaker, a love for process and the materials has always been tied to the uniqueness and meaning of the final work. For me, it is important to keep a connection to my art, and so handprinting remains a vital part of the process. It is in the printing process that further choices and changes are made that just cannot be achieved by mechanically printing out what you see on the computer monitor.

"My interest in computer usage for printmaking led me to Adobe Photoshop. My use of the computer is not as strictly mechanical or technical as it is for the four-color process reproduction of art or photographs for books. Decisions and hand-additions or modifications are needed when actually printing the screenprint."

Computer and Software

Whether Mac or PC, your computer has to run Adobe Photoshop and handle large color images without freezing or "bogging down." Hellman's suggestions allow the flexibility to create images up to 13- x 19-inches at resolutions of 200 pixels per inch (ppi). A computer that does not require proprietary parts allows for easy upgrades.

The minimum equipment needed to work efficiently is a 17-inch monitor, 1.42-gigabyte (GB) processor chip, 40-GB hard drive, 64-megabyte (MB) graphics (video) card, and 1 GB of RAM (memory).

The image's resolution, dimensions, number of layers, and channels and whether it is black-and-white or color affects the image file size. The larger the file, the longer opening and saving images and using filters takes. Also purchase an external storage device, such as a 250-MB zip drive, a USB Flash memory card, or rewritable CD-ROM drive for storing large files, both to back them up and to remove the drain from your hard drive. When working from large images, copy them from the disk to your computer's desktop, from which they will open and save more quickly.

Software

Painting programs like Adobe Photoshop and Corel Painter work with pixelated (rasterized) images, or tiny blocks or pixels of different values or colors, that make up the image. Drawing programs like Adobe Illustrator, Corel Draw, and Aldus Freehand create smooth, nonpixelated images through a mathematical vector-based (object-oriented) system. They are not used to manipulate photographs.

Hellman's experience is that images created in Photoshop at 200ppi result in smooth screenprinted shapes even under some magnification. So, for the sake of simplicity, Adobe Photoshop is his program of choice, and he tries to do everything within it rather than exporting images into other programs like Adobe Illustrator. There is a definite learning curve, and as an artist, you have to decide how much time you are willing to invest to learn Photoshop, no less other programs. Photoshop is continually being upgraded.

Varying Resolutions

This is a comparison of an image at different resolutions, from 72ppi at left to 300ppi at right. The higher the resolution, the more pixels per inch, so the smaller the pixel units are. The result is finer detail and smoother, more natural edges.

Vector Shape

Vector shapes have no pixels and remain smooth even when enlarged.

Printing Separations

Photocopy stores can print your work on clear acetate, but they may not stock larger film than for 8 ½- x 11-inch images, and you may need to print on and expose through paper if you need a bigger image. Request that the marks be made as opaque as possible because the layer of toner they use often is not dense enough. Specify the dot frequency, typically 55 lines per inch (lpi) or below for screenprinting if you want halftones.

Inkjet printers are commonly available in desktop models capable of printing media of 13- x 19-inches and 17- x 22-inches. For painting with various brush tips, creating hard-edged designs, even creating artistic halftones and other graphic conversions within Photoshop, a standard printer today will usually print an adequate black for exposing a screen to photo emulsion.

If you want denser blacks and the ability to print vector shapes, crisper type, and more controlled halftones for reproducing an original photograph or artwork, as in the T-shirt industry, you will want a printer that has Postscript capabilities and a Raster Image Processor (RIP). Introduced by Adobe in 1985, Postscript is a "page description language" that can be encapsulated in a file and describes images in a device-independent way—that is, it will print that information at your printer's highest resolution, regardless of what the resolution of your file is. RIP software is also needed for inkjets to print halftones directly. A RIP works along with Postscript to interpret vector images into rasterized form. It creates smoother type, halftones, and gradations than the images an inkjet normally would create.

Epson has become a leader in manufacturing inkjet printers for artists and small graphics businesses. These printers can be out-fitted after market to act like smaller versions of the quite expensive high-end image setters used in the printing industry to create film positives on clear film.

Two such excellent modified new-model photo printers available are Epson Stylus Color R1800 for 13- x 19-inch image printing and Epson Stylus Pro 4800 for 17- x 22-inch image printing (*visit www.usscreen.com to see the latest available model*). Older, and less expensive models like the Stylus 1520 for 13- x 19-inch image printing or Stylus 3000 for 17- x 22-inch image printing have been very popular with T-shirt screenprinters, and refurbished models may still be available (*visit www.squaredot.com*).

Laser printers typically hold paper from 8 ½- x 11-inches to 11- x 17-inches and produce good results. Apple LaserWriter and HP Laser Jet with Postscript capabilities print good halftones. Unlike inkjet printers, they do not need RIP software. Laser printers use heat to set the toner, so print only on surfaces designated for use with laser printers.

The Xanté ScreenWriter 4 is a laser printer made expressly for outputting film positives for screenprinting. It can print on 13-inch wide media—either vellum or clear polyester film—and is available with printing resolutions of 600 x 600 dots per inch (dpi) to 2400 x 2400dpi. It comes with Adobe Postscript Level 3 and prints excellent halftones and gradations. An available processor increases the density of the toner if you find you need it.

What to Consider When Buying a Printer

How large is the printing area? Some printers can handle 17- x 22-inch media, as an example, but may print only a 13- x 19-inch area. What is the "optical" (true) resolution of the printer? Most printers today are more than adequate. How fast will it print? How much memory does the printer come with? Can you upgrade it if you need to in the future? Is the printer compatible with your platform (PC or MAC), and do the cable connections work with your computer? Can this printer use large black ink reservoirs, especially if you plan to create many separations? Can the printer handle media of different weights? If you are looking at a wide-format printer (more than 24 inches wide), does it require opaque "sensor strips" on clear media in order to "see" it? Can the printer be purchased with Postscript capabilities, and is there a RIP option available, as Postscript capability on inkjets does not automatically mean it can read halftones?

Paper Media

Choose media—the surface onto which you are printing—that will not melt, shrink, or smear your ink. Keep it in a sealable plastic bag to prevent it from absorbing moisture, which would cause it to expand. Laser printers and copiers require media that is made to withstand the heat created to fuse the toner. Art supply acetate will melt. Look for overhead projector transparency sheets at office supply stores that typically stock only 8 ½- x 11-inch sizes. A more professional film for separations is made from polyester to avoid shrinkage and can be bought in sheets in a variety of standardized printer sizes from online venders like Caseys Page Mill (*visit www.caseyspm.com*). Another, less expensive choice is a vellum-like material called Translucency.

Inkjet printers can print on the appropriate 8 ½- x 11-inch-overhead-projector transparency sheets that have been specially coated to quickly dry the ink. Regular art store acetate, again, will not work well because the ink doesn't dry and will smear. White copier paper can be used, of course, in either type of printer, but it requires much longer exposure times. Standardized larger films that give superior results are also available online from Caseys Page Mill, www.screenprinters.net, and www.victoryfactory.com (*see Resources on page 141*).

Artists have used textured films like Lexan and Autotex for years to expose handdrawn tusches onto photo printmaking plates or screens because they capture more detail in the gray values as random dot patterns. For the experimental at heart, some of these films are available with inkjet receptive coatings by special order. While test results of exposing continuous tones printed on these films did indicate some promise, the results were not as predictable as when first creating high-contrast images in the computer and printing on clear film. At this time, these films are only available in widths from 36 inches and up, as they are designed for industrial use for wide-format printers. They have to be cut down, therefore, for smaller printers, making an initial purchase somewhat expensive and inconvenient.

Special Effect Plug-Ins

Hellman used the Andromeda #3 Screens filter to create the mezzotint effect at top and the Decalmania 45dpi to create the image above.

Printing Halftones onto Textured Film

Hellman printed the continuous-tone image at far left onto Autotex film, known as True-Grain in the United Kingdom) on a Canon Pixima iP-4000 inkjet printer. He then exposed the separation onto a screen coated with Ulano RLX emulsion and screenprinted the image in blue ink, shown at left. The textured plastic created its own dot pattern, capturing some of the light values.

Using Photoshop

The WACOM Intuos3 digitized tablet allows you to draw with a stylus instead of a mouse. The pressure-sensitive stylus provides greater control over the width and value of your marks. The 6- x 8-inch drawing palette is adequate to work on a 17-inch monitor screen.

Many other companies sell separate plug-in software designed to enhance and broaden specific Photoshop functions. Visit www.andromeda.com to see its useful line of graphic plug-ins. The Screens Filter, Cutline Filter, and Etchtone Filter break continuous-tone images into sophisticated, all black-and-white graphic conversions which you can then transfer to your screen with photo emulsion.

Use Photoshop to draw direct marks and textures, create hard-edged shapes on separate layers, try different colors and work out composition. Scan in photographs, tusches, textures, or other artwork, then modify them using tone controls, filters, and expanded painting tools. Apply special-effect filters to manipulate images and convert continuous-tone images to "line art," and other high-contrast graphic conversions like halftones, mezzotint-like random-dot dithers, or posterizations. Move the boundaries of selected shapes for trapping and print photo-positives for transfer to your screens.

Save your work frequently as you progress to avoid losing anything in the event of a computer freeze or power problem. Make duplicates of your images at important stages for later reference. One easy way to do this is to open the History Palette and click on the left, bottom Create New Document from Current State icon. Save as a regular Photoshop file (psd) or TIFF (tif), but not as a JPEG (jpg). The JPEG file format does not save layers and channels and will lose information when frequently opened and closed.

When you scan in a photograph, or open a new window to work in, you need to set the resolution of the image. As reference, 72ppi is coarse and 600ppi is much finer. The resolution you will set depends on what kind of art you are working with and how it will be printed. For screenprinting, matching the artwork to the appropriate screen mesh and squeegee hardness is also a factor, so have screens with different meshes—195, 230, 305—and squeegees of medium and hard durometers available. Important factors concerning printability are whether marks are coarse or fine, the space between them needed to avoid filling in detail, and the finish of the printing paper. We have all seen examples of newspaper "photographs" that have filled in because the dots were too small and close together for the absorbent newsprint. In the printing industry, this ink spread is called "dot gain."

The rule of thumb suggested in many books on Photoshop is that to maximize the tonal range of a halftone, you only need to scan at 1.4 to 2 times the halftone frequency (dot size). For screenprinting, which typically uses relatively coarse dots of 55lpi or below, you would, therefore, only need to scan a photo at a maximum of 110ppi when printing on an average printer. However, a hard-edged image requires a resolution of at least 200ppi to avoid jagged edges and provide more control for trapping.

For simplicity, Hellman creates all his digital images at 200dpi and then makes duplicates on which he can experiment with posterizing, mezzotints, halftones, and dithers. While this may sacrifice some tonal range, when scanning for halftoning, he prefers to get more fine-line detail, and a higher contrast gives more "punch" to the graphic image. You can always lower the output resolution.

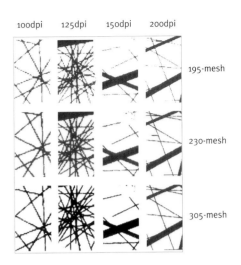

One Pixel, Different Resolutions

Hellman printed a one-pixel-thick line at various resolutions and on various screens. These results support the general use of 230 threads-per-inch mesh, with 305 used for very fine detail, and 195 for broad flat areas.

Resampling

In the Image Size window, check "Resample Image" and then reduce the image size to keep the resolution the same; basically, you are removing pixels. Unchecking the box retains all information by increasing the resolution as you reduce the size.

Converting Continuous Tone to Line

"Line art" refers to all black, high-contrast art. There are a number of ways to change continuous-tone images to high contrast using tonal adjustments, filters, or bitmap mode. Sometimes, combining more than one operation yields results with more detail than applying just one.

Click on Image in the Photoshop Menu at the top of your screen, then Adjustments. Experiment with Threshold, Brightness/Contrast, Levels, Invert, Posterize, and Curves.

Making a Line Shot

To simulate a copy camera "line shot," use the Threshold command to break the image down into only black and white with no continuous tones. Adjust the slider to change the distribution of white and black. Threshold abstracts the continuous image by pushing grays into either the white camp or black camp, resulting in a strong, high-contrast graphic image.

There are a number of other ways to change an image toward higher contrast that are not as radical as the Threshold command and will hold more detail as texture. Overapplying the Unsharp Mask Filter, sometimes sequentially to the image, is one of Hellman's favorite methods. Applying Levels, the Mezzotint Filter (under Pixelate), Diffusion Dither (Bitmap Mode), and combinations of these are some other examples.

Threshold

Increase an image's contrast for use with photo emulsion.

Unsharp Mask Filter

Select Filter, then Sharpen, then Unsharp Mask to sharpen a scan or to increase the contrast by moving the amount and radius sliders way to the right, "overapplying" them.

Adjusting Tone

Brightness/Contrast is used for very simple contrast adjustments by moving two sliders back and forth. However, when you need finer control, the Levels command is a more sensitive tool.

The Input Graph shows the distribution of black (left side) and white (right side) in an image. Space between the left triangle slider and the beginning of the black graph indicates a lack of 100 percent black, and the same goes for the right side with respect to pure white. To include pure black and white in the image, move the sliders inward until they touch the graph, and then adjust the middle (midtone slider). The more you move the sliders toward the center, the more grays you eliminate, creating higher contrast.

However, If you want to maintain the illusion of photographic continuous tone, converting your fully-toned image to a diffusion dither or a halftone is a good graphic solution, and adjusting the original image to its highest contrast is not advantageous.

Levels Window

An output level of zero represents black, and 255 represents white. For dithers and halftones, lighten the image to protect detail in dark areas and slightly darken whites to prevent highlights from washing out.

Increasing Contrast

Hellman manipulated this image in stages, moving the Levels Input sliders to 93 on the left and 180 on the right to increase contrast. Then he applied Unsharp Mask twice, and then 50 percent Threshold to remove all remaining gray pixels.

Diffusion Dither

Go to Image, Mode, Grayscale, Bitmap, Diffusion Dither. A diffusion dither is an artistic looking random-dot halftone pattern that simulates continuous tone by placing small, irregular, mezzotint-like marks closer or farther apart. The size of the marks stays the same.

A good rule of thumb is: If the continuous-tone image looks good on the monitor, it will probably screenprint too dark and lose detail due to ink spread after conversion to dither or halftone. To compensate, lighten blacks (left Output Levels slider) to create detail in the shadow areas prior to dithering. Try typing 25 to 35 in the left box (or manually moving the slider inward) to lighten black to a dark gray. Changing the right Output Levels from 255 to 245 would put small dots in the highlights so they don't "pop." One simple test is to print your image on an inkjet printer using typewriter paper. Whether the detail fills in is an indication of what will happen when screenprinting. If it looks "filled in," undo the dither or halftone and lighten the blacks more. You may also need to lower the resolution to make the marks bigger.

To apply the Diffusion Dither, you must first change the image to Grayscale Mode, then Bitmap Mode. The dialog box will display the resolution at which you scanned the image. Set the output resolution according to the printable dot size for the mesh count of your screen. To determine this number, a ball-park formula is to divide the mesh count you are using by four to get the maximum dpi to a rounded number, then double the number.

For example, using a screen mesh of 195 threads-per-inch, divide by four, giving a maximum of a 50dpi halftone dot. Then, multiply by two to get 100 or 110ppi resolution; change the output box accordingly. If you were to leave the

Bitmap Box

Pressing on arrow under Method allows you to choose Diffusion Dither, Halftone, or 50 percent Threshold.

Diffusion Dither

After applying a diffusion dither, revert back to Grayscale Mode from Bitmap Mode to continue editing the image.

Original Photo

This color photo does not seem at first to have potential for conversion to high contrast.

Grayscale

Change the image to Grayscale Mode.

Unsharp Mask

Overapply Unsharp Mask Filter.

resolution at 200dpi (what you scanned at), the detail would definitely look better on the monitor, but when printing, the 195 screen would not hold the detail. Reduce the resolution in the Output box to increase the size of the marks, and/or use a finer mesh fabric. Having screens at 195, 230, and 305 at hand gives you more flexibility to print different kinds of artwork. Through practice, you will find what works with your particular inks, paper, printing ability, and humidity conditions.

Note that after you apply a dither, what you see on the screen will usually look coarser than how your positive will print. Go to View, Actual Pixels to see a more accurate idea of what the marks in the dither will look like. If need be, undo and lighten the darks using Levels, and reapply the dither. Print a test onto typewriter paper using an inkjet printer to see if it fills in.

Threshold

Image, Adjust, Threshold.

Combining Techniques

Unsharp Mask plus Pixelate Filter, Mezzotint, Long Lines.

Combining Techniques

Unsharp Mask + Threshold.

Combining Techniques

Close-Up of Unsharp Mask Filter plus Threshold.

Combining Techniques

Levels plus Threshold.

Combining Techniques

Levels plus Diffusion Dither.

Working with Brushes

A separate set of options appears in the Options menu for each tool in the Photoshop floating tool palette. Approach tonal adjustments on brush marks as you would photographs or any continuous-tone image, coaxing them to higher contrast while trying to retain detail.

Setting the Mode to Dissolve in the Options menu draws pixels that are solid black. This is a good place to start experimenting because what you see is what you get. Experiment with different brushes. Try a regular brush versus the airbrush, or adjust the flow percentage to see what the texture looks like using a large brush diameter versus a small one. Compare marks made by clicking the mouse versus holding and drawing a line.

Pressing on the arrow to the right of the word "brush" near the left side of the horizontal Options Bar reveals different "Preset" choices (the shortcut is to right-click on any image while the Brush tool is selected). Then, clicking on the arrow in the upper right corner of the palette reveals a list of different libraries of brush tips to select. There are also slider controls for the diameter of the brush tip and its hardness.

A quick way to adjust the size of the tip when using a mouse is by pressing the two bracket keys, located just to the right of the P key with your other hand. The left one reduces the brush tip; the right one increases the size. When using a WACOM Pen, Hellman likes to set the bracket keys to coordinate with the little "clicker" on it.

Comparison of Marks and Screens

Printed on 195 screen mesh at left, the 100dpi one-pixel-thick line is visibly jagged, while the 200dpi one-pixel lines lose detail because the coarser threads of the 195 mesh screen partially blocks them. Notice the distracting pattern being picked up. Printing with 230 screen mesh (middle) yields a substantial improvement in the detail. In the 200dpi resolution, there is a slight loss of detail, yet the results are still pleasing, giving a softer look. Printing on 305 screen mesh, on the right, yields more fine-line detail and picks up more dots at all resolutions.

Brush Palette

Activate the Brush Palette by pressing the F5 key or Toggle in the Brushes icon in the top right corner of the Options Bar. Click on Brush Tip Shapes in the Brush Palette. Click on the arrow in the upper right to reveal a menu and choose Special Effect Brushes. Choose Soft Round Brush 21. Then Click on "Dual Brushes" to highlight its name and put a check in the box. Select the Zig-Zag shaped tip labeled Sample Tip 22 and use Mode to Multiply at the top. Move the Spacing (try 77 percent) and Diameter sliders (46 percent) to suit. To save the Dual Brush settings, click on the New Brush Icon at the bottom next to the trash can and give it a name, such as Barbed Wire21. A picture of it will now appear in the Presets menu you are in (Special Effects Brushes).

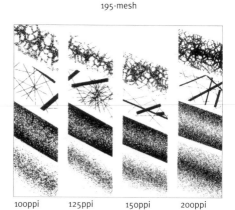

195-mesh

100ppi 125ppi 150ppi 200ppi

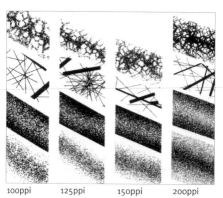

230-mesh

100ppi 125ppi 150ppi 200ppi

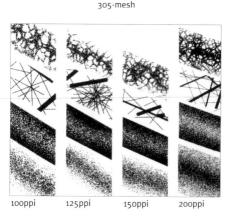

305-mesh

100ppi 125ppi 150ppi 200ppi

On the previous page are screenprinted comparisons of marks made with similar brushes at 100, 125, 150, and 200ppi resolutions to see which of the commonly used 195, 230, and 305 screen meshes would print the smallest marks and best detail of each resolution.

When you feel comfortable investigating and experimenting with these options, there are many more controls in the Brush Palette. To reveal it, press the F5 key or click on the Brush "toggle" icon located about two inches to the right of the airbrush icon on the Options bar. At the top left of the Brushes window that will open are tabs for Brush Presets and Brush Tip Shape. Below these are extensive brush controls, such as Shape Dynamics, which requires the WACOM Pen Tablet, Scattering, Texture, and Dual Brushes.

In contrast to using Presets, pressing on the Brush Tip Shape tab allows you to choose your brush and then experiment with these other options. Holding your mouse cursor over the image of the brush tip reveals its name. Pressing on the arrow in the upper right reveals a menu of different Brush Libraries. The number of the brush tip only refers to its diameter in pixels. Therefore, there may be several brushes with the same number, so when making notes, also write down the brush tip name and the menu from which you got it. Acquaint yourself with the features by reading an overview in the Help Menu or a book and by experimenting. Examples of some interesting results appear on these pages.

Custom Brush

Choose Textured Brushes. Click on Brush Tip Shapes and choose Soft Round 200. Then, under Dual Brushes, choose Sample Tip 90, which looks textured. Select Multiply Mode.

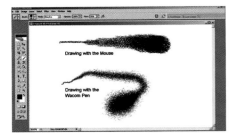

Dissolve Mode

Hellman made the top image by drawing in Dissolve Mode with a mouse and a WACOM Pen at the bottom. The Brush Options Bar appears on the left.

Custom Brush

In Textured Brushes, choose the Spatter 39 Brush Tip Shape. Leave Dual Brushes on Sample Tip 90. The tapered effect was achieved by using the Shape Dynamics choice and a WACOM Pen.

Custom Brush

Choose Soft Round 100 in Textured Brushes. Press the Airbrush Tool Icon in the Options Bar with a flow of 8 percent, and change Mode to Dissolve. Draw by clicking for short or longer bursts. I applied a Twirl filter to the bottom shape.

Custom Brush

Hellman achieved this effect by drawing through a large stroke with the Smudge tool in Normal Mode. Then I applied the Unsharp Mask multiple times at a high setting to increase contrast.

Creative "Fills"

Using the Rectangular Marquee Tool, Hellman created long selections. With the shapes active, he dragged the Gradient Tool left to right, creating a smooth gradation of value. Then Hellman applied the following effects from the Filter Menu, Pixelate, Mezzotint using Grainy Dots at top; Sketch, Reticulation at middle; and Texture, Craquelure at bottom. The last two required tweaking with tonal adjustments to bring them up to high contrast.

Changing Continuous Tone to Halftone

Magazines and newspapers use halftone dots to convert continuous-tone photographs into ink-printable form. The size of the dots and the white space between them create the illusion of continuous tone. Again, an image that looks good on your monitor probably will print too dark, so when converting to a halftone, dither, or mezzotint, compensate by lightening the shadow areas and lowering the highlights slightly using the Levels Output box. An easy way to apply a large-dot halftone to a grayscale image is with the Color Halftone Filter.

Halftone Filter Under the Pixelate Menu

To apply it to a color RGB image, you must first change to CMYK mode. RGB refers to color light primaries Red, Green, and Blue, and CMYK refers to the traditional four plates lithographers use with ink process colors—cyan, magenta, yellow, and black. When printing these separations, open the Channels window, click the arrow in the upper right, and choose Split Channels. The four CMYK channels will appear already changed to black. You may want to duplicate the image for reference before splitting channels, as the change is irreversible.

Making Halftones in Photoshop

Go to Image, Mode, Grayscale, Bitmap, Halftone. One major problem with creating halftones in Photoshop, as opposed to letting a Postscript printer do it at the time of printing, is that seeing a clear and undistorted dot pattern on the monitor screen can be hit or miss. It is one of Photoshop's quirks that the output resolution needs to be set substantially higher than the input in the Bitmap window when making halftones, and it takes some experimenting. This is not the case for making dithers. The settings that Hellman developed, listed below, serve as helpful guides, but they may not work in every case. The larger the image, the less difference you need between the input and output resolutions.

If you need extremely accurate reproductive color halftone separations, invest in color separation and color management software and a printer that has Postscript and RIP capabilities.

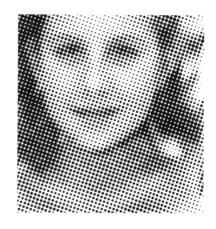

Applying Halftone

This is a coarse halftone made with the Color Halftone Filter under the Pixelate menu.

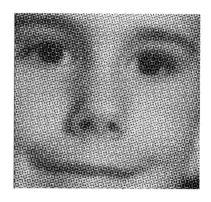

Applying Halftone to Color

The Color Halftone Filter produces a bold, graphic interpretation best used on large images because the dots are big.

CMYK

This close-up of the eye in the above image shows how the four process colors—cyan, magenta, yellow, and black—combine to create other colors and deeper shadows.

Size of Image	Input Resolution	Output Resolution	Frequency	Results
3" x 3"	100ppi	400ppi	24dpi	Good
4" x 6"	100ppi	400ppi	35dpi	Good
4" x 6"	200ppi	800ppi	35dpi	Good
10" x 12"	100ppi	400ppi	35dpi	Good
10" x 12"	200ppi	400ppi	35dpi	Good
10" x 13"	200ppi	300ppi	55dpi	Good
20" x 22"	100ppi	200ppi	35 & 55dpi	Good
20" x 22"	200ppi	200ppi	35 & 55dpi	Good
20" x 22"	200ppi	400ppi	35 & 55dpi	Distorted

More Halftone Issues

Another important issue which makes using Dithers and Mezzotints attractive to artists is that they are easier to work with on screens than halftones. The regular dot pattern of halftones, when superimposed on the pattern of the screen mesh, tends to create an interference pattern known as a Moiré. Adjusting the screen angles in relation to the screen mesh to limit the Moiré effect becomes a primary concern for the screenprinter in color halftone work.

The Rosette pattern is least bothersome to the eye and is formed by placing the contrasting colors of cyan, magenta, and black at 30 degrees to each other, with yellow at 15 degrees from one of these.

Typically, you find larger dots (55dpi and below) in screenprints because they are so much easier to print. The smaller the dot, the finer the mesh you need, and handprinting with consistency becomes difficult.

Color halftone reproduction is a complex topic and a science unto itself, beyond the scope of this introduction. In the screenprinting industry, in which the goal is to replicate an original, you can use Photoshop to adjust for dot gain, brand of ink, and other things related to color management.

Black and White Halftone

Hellman changed a Grayscale image to Bitmap Mode and selected halftone. The dot size, or screen frequency, was set for 24; the angle 45 degrees, and elliptical dot. The Input resolution was 100ppi, and the output resolution set for 400ppi.

Offsetting the Screen Angles

This is one popular configuration created by adding 7.5 degrees to the traditional angles used in offset lithography to try to eliminate the visual conflict between the screen mesh and the dot pattern. After choosing Halftone in the Bitmap box, enter these numbers for the appropriate color.

Halftone with Small Dots

This 133lpi halftone prints well in a book with coated paper, but is too fine for screenprinting without losing detail. Other printmaking methods like photogravure using Solarplate or ImageOn film might very well be able to hold this fine dot. A 55lpi (or below) is much more common in screenprinting.

Custom-Pattern Halftone

This is a playful example of using the Custom Pattern Halftone choice in the Bitmap Window. Create the custom pattern under Edit, Define Pattern.

Moiré Pattern

Moiré pattern created by superimposing two pieces of common door screening. Eliminate it by rotating the angle of the screens.

Posterizing an Image

Go to Image, Adjust, Posterize to break a continuous tone black-and-white image into the number of separations you want to screenprint, creating an artistic, high-contrast, graphic interpretation. Selecting five values, as an example, would give black, white, and three grays. Type in the number of values you want, then use the up and down arrows on the keyboard as a shortcut to increase or decrease that number, looking for the most satisfactory compromise between the number of separations, pattern, and detail. Staying within a range of three to seven values gives a good posterized look.

When you are satisfied with the results, select each value, open a new layer (clicking the icon to the left of the trash can in the Layers Palette), and fill it with 100 percent black. Remember that even though you may want to screenprint each separation a different gray or color, you must prepare them as all black-and-white photo-positives to affect the photo emulsion. To avoid trapping, it's easiest to print the combined image in the lightest color and continue to overprint each successively dark color as you would when creating a reduction print.

You can posterize a color image, but the process on a black-and-white image is far more direct.

To select Different Value or Color Shapes, use the Magic Wand or Color Range tool. Choose the Magic Wand tool in the Tool Palette. Adjust the tolerance to one and the eyedropper tool to Point Sample in the Options Bar. Use the Magnifying Glass tool to enlarge the image and click on a value. Then click on Select in the Photoshop Menu and choose Similar. This will place the selection "marching ants" around all the same valued shapes. To add other values to enlarge the shape, press the Shift key and click on the other value.

Go to Select, Color Range for another excellent tool. As you move the cursor over your image, it changes to an eyedropper. Use it to select one of the colors or values. The Fuzziness slider allows you increase the selection, but keeping it all the way to the left will select just one value or color. Click on the icon of the eyedropper with a + sign, and then other values to add them to the selection. Other colors will then be selected to be printed on top.

Saving Selections

With the selection marks active, open a new layer and fill it with 100 percent black (Edit, Fill). It is helpful to go in some order, such as light to dark, and label the new layers (double-clicking on the name) with some

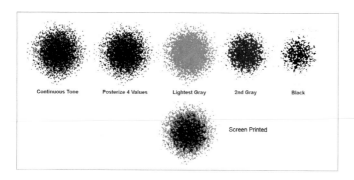

Four-Value Posterization

Hellman used the Airbrush tool to apply a continuous-tone brush mark. The shape of the lightest gray matches the combined shape of the second gray plus black; the unprinted paper makes up the white areas.

Color Range Window

Press the + key and use the eyedropper tool to combine several colors. Other colors will then be selected to be printed on top.

designation that will keep you from getting confused. Or click on Select in the Photoshop Menu, then Save Selection. Type in a name. Press OK. The selection will appear as an all black shape in the Channels window.

Color Image

When working with a color image, the most direct way is to change it to Grayscale Mode, apply the Posterize command, and assign colors to the different grays when printing. Using the Posterize command directly on RGB color images is not as direct: A setting of five applies changes to each color channel, resulting in many more than five colors. If you are looking for about seven to twelve colors that are closer to the original, there are other ways to do this.

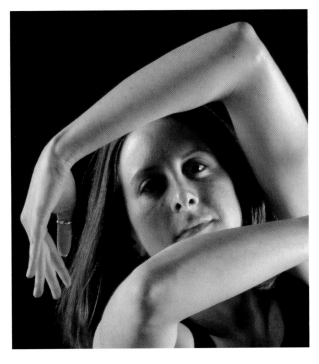

Original Image

Start with a continuous-tone color image.

Black-and-White Posterization

Hellman created a five-value posterization of the original image after changing it to grayscale.

Close Up

Hellman posterized five values directly from RGB Mode, which yields more than five colors.

Other Posterizing Methods

Go to Index Color, Image, Mode, Index Color to provide a limited 256-color palette, which is typically used for Web design. Choose palette type, Local (Adaptive), and enter the number of colors to match the number of separations you want to use. This palette type samples colors that are the most common to your image.

Set the Dither Box to None to achieve flat color shapes. Selecting Dither instead would blend between color areas by creating a square-dot halftone useful for avoiding Moiré patterns. (*see Resources on page 141*) for more information on square-dot halftones).

Color images with a close color scheme may work fine with five to seven values, while others with wider original color ranges may lose important detail unless you are willing to increase the number of colors. To limit the number of colors, click Photoshop's Rectangular Marquee tool, then drag a rectangle over the area you are trying to preserve, such as the sky, and then apply Index Color. Change back to RGB Mode when done.

Another method is to switch from RGB to Lab Color Mode—go to Image, Mode, Lab Color—which allows you to work directly on the grayscale values without changing to Grayscale Mode. Click on the Lightness Bar in the Channels window and apply the Posterize command directly to this black-and-white channel. Then change back to RGB Mode, then to Index Color Mode, and use the up and down arrow keys to experiment with values. When finished setting the Index Mode, switch back to RGB Mode.

To save an experiment and continue working, click on the Snapshot or Make Image in Own Window icon at the bottom of the History Palette.

To experiment with Arbitrary Color Combinations, Hellman applied the Posterize command directly to the RGB image and experimented with different palette choices and other techniques.

Index Color Window

Set for Local (Adaptive) palette.

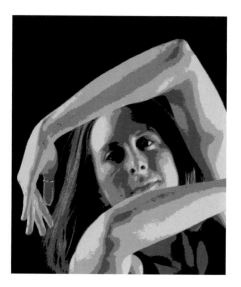

Five-Color Index

Hellman made this simplified color posterization by setting the Local (Adaptive) Palette to five.

Color Posterization

At left, Hellman applied three values directly to the RGB image, then Index Color with six colors with the Master (Perceptual) Palette. In the middle, he applied three values directly to the RGB; then Index Color with nine colors with the Master (Adaptive) Palette. At right, he applied four values directly to the RGB image, then Image, then Adjust, then Gradient Map.

Original Continuous-Tone Color Image

Compare the manipulated images that follow to this original.

Eight-Color Index

Limiting colors to eight caused the sky to lose detail.

Compromise

To find a compromise between the number of separations needed and detail, Hellman posterized the Lightness Channel in Lab Mode, then changed to Index Color Mode with twelve colors using the Rectangle Marquee in the sky to preserve the colors.

Save Selection Window

Hellman selected the white shapes to print for a separation.

Counterpose Series #1, Richard Hellman, 22" x 30"

Hellman made the separations for this image, printed with Speedball inks, with the computer.

Counterpose Series #2, Richard Hellman, 22" x 30"

The separations for this print were made on the computer, printed on film and then printed with Speedball and Createx inks.

Trapping Digital Images

When printing one color over another, maximum color strength is compromised unless the top color is very opaque. If the overprinting is too transparent, you need to have the white paper beneath it to achieve maximum strength, and trapping becomes an issue.

When trapping digital images, consider whether one shape completely surrounds another, if they butt up next to each other or if they just partially overlap.

Trapping a Surrounded Shape

Hellman creates complete shapes in separate layers, such as the black square and yellow circle here. Knock-out (remove) the black that is underneath the yellow circle. Select the yellow shape through an easy shortcut by control-clicking (command on a Mac) on its thumbnail in the Layers Palette. Then click on the black layer icon and press delete. Expand the yellow circle by, say, eight pixels by going to Select, Modify, Expand. Then, fill the expanded shape with yellow.

The image's resolution will determine the number of pixels by which you should expand the shape. A low-resolution, such as 72ppi, has big pixels, so one pixel could be way too much. For this reason and to avoid jagged edges and shape distortions, use a 200 to 225ppi image if you plan to trap. The higher the resolution, the more pixels by which you will need to expand the shape. ½- to ⅟₁₆-inch typically avoids large overlaps.

Multiply the resolution by the number of inches by which you want to expand to get an exact pixel count. To create a ½-inch trap at a resolution of 200ppi, for example, divide 200 by 32, which yields six. Test the trap by selecting part of a shape and expanding or contracting it, and printing. Then modify as necessary.

Expanding a selection expands all the shape's borders, so this trapping technique overcompensates when only parts of the shapes overlap.

Knock-Out

First a black square was created, then the black directly under the yellow shape was removed from the square.

Expand the Background Color

You will expand the yellow circle out to the dotted line, and by screenprinting the yellow first and then the black shape, with the circle knocked out, you guarantee that the two colors will meet, without the white screen peeking between them.

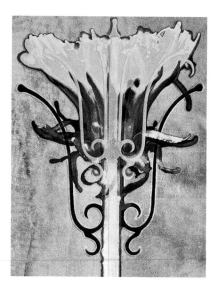

Wellspring, Stephanie Hunder, 14" x 11"

This fourteen-color screenprint was made from digital films taken from a digital image composed of an original photo and an appropriated image of a coat rack.

Trapping Partially Overlapping Shapes

If you have prepared the image properly, Photoshop can trap automatically in CMYK Mode. In order to do this, Hellman's method involves saving active selections of shapes that only partially overlap, as spot color channels. When working with many spot color channels, selecting two spot channel bars helps control which colors trap under which.

Channels are listed in the order in which a lithographer would print them, which is opposite the order of layers. When you have selected two spot color channels, the top one expands under the other. As you trap multiple layers, you may need to rearrange the order to prepare for the next trap.

Trapping Overlapping Shapes

To print a vibrant yellow, you will need to trap it under the purple, red, and black circles.

Knock Out

Select the yellow triangle and, with that selection active, hold the shift key while clicking on the purple, black, an red layer icons. Then press delete.

Correct Trap

Expand the yellow only where it overlaps the purple, black, and red, resulting in a shape like this example,

Expanding the Triangle

Expanding the entire triangle does result in the corners being trapped, but the triangle's edges do not remain straight.

The Trapping Process

To bring all color layers into channels as spot colors, open the Channels and Layers palettes. With its eye visible, click on the layer icon of the color you want to make into a spot channel. Press control and click on its thumbnail, which is a shortcut to load the selection. Select the triangle as the foreground color in the floating tool palette using the eyedropper. Click on the triangle color icon to open the Color Picker. Notice I then highlighted and copied the "hex color identification number" as a shortcut to pick the same color for the spot channel.

With the selection still active, click on the arrow in the upper right of the Channels palette and select New Spot Color. Type yellow or the color with which you are working into the Name box. Then click on the color box, which will display the previous color. To make it the color you want, highlight the color code and paste the hex identification number you just copied. Leave the percentage at 100 for a solid color or change it to 50 for transparent color. This does not affect the colors but helps you visualize the image. Repeat for each pair of the trapped colors. Switch from RGB Mode to CMYK mode so you can use the trap command. Save a copy with the layers intact using another name to help you identify them when you need to flatten them later. To trap the triangle in the example on this page under the purple circle, move yellow above purple in the Channel palette. Select both channels, then go to Trap under the Image menu.

Fill in the trap units here following the formula on page 136. For an image at 200 ppi, six pixels will extend the trap about ½-inch. You can set the trap by points (72 to an inch) or millimeters instead of pixels. These measurements, unlike pixels, expand by the same distance regardless of the image's resolution. Check the traps using the magnifying glass in the floating tool palette as you may need to touch them up. The type of paper you print on, the type of ink you use, the humidity, and your skill level may require a larger trap than. With experience, you will know what works for you.

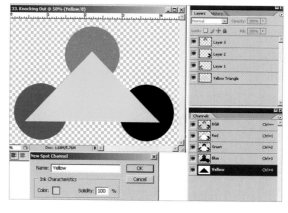

Saving a New Spot Channel

In the New Spot Channel, Hellman named the spot channel Yellow and left the color solidity at 100 percent.

Color Picker Window

The hex number that refers to the yellow I want for my spot channel is highlighted, ready to be copied.

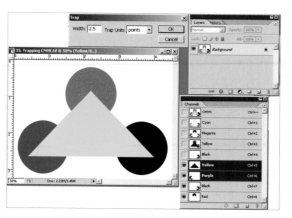

Trapping Each Pair of Colors

After saving all spot channels, select a pair of colors to trap.

Printing the Separations

Close the original four CMYK channels. With all the spot channels visible, meaning the eyes are showing, you still will be able to see the image in full color. When you click on each channel and print it, though, it should print in black so you can print onto clear film. To make sure they will print in black, click the arrow in the upper right corner of the Channels palette and select Split Channels. Each channel will appear in black-and-white in the order listed in the Channels palette.

Label each separation with the appropriate color to avoid mistakes later. Print on the correct side, which will be sticky if you touch it with a wet finger, of clear media.

Untitled (Safety Video), Marc Lepson, 22" x 30"

The photos for this print were scanned into Adobe Photoshop and the color was adjusted. Then they were printed as four-color CMYK separations onto an 8 ½- x 11-inch laser printer. The four separations were then enlarged 400 percent onto vellum at a photocopy center, put on screens and printed with TW Graphics ink.

Bus Driver, Marc Lepson, 22" x 30"

This close-up print was created following the same process as *Untitled (Safety Video)* above.

Registering the Separations

The size of the finished print; the distribution of a color across the stencil; the shapes, whether grounded or floating; and how many separations you can fit on one computer printer sheet will determine your registration method. If you choose to print and expose targets in the same place on each stencil, place them outside the squeegee's reach so they will not appear on your final print.

Under the File Menu, go to Print With Preview, and select Labels, Crop Marks, or Register Marks. Labels will help you avoid confusing your stencils. To create bold targets, as opposed to the thin ones that print automatically, use the Custom Shape tool by clicking the icon under the Type tool. Scroll through the box that comes up to select. Make a separate layer for the targets so you can print each individual spot channel or other layer with the targets located in the exact same place.

Make the canvas size ¾-inch to three inches larger to create a border for the target. Targets take up printable area you might want to use for your actual image, so Hellman suggests registering using other methods, such as knocking out areas into which a shape fits for visual reference, when possible.

To correctly place floating shapes that you will print in a light color, tape a clear, heavy, .010 Mylar sheet with a long hinge flap over the entire printing surface and print a proof on it. Then punch holes for a registration bar in the actual print's paper, tape the separation to the print and place them under the Mylar. Align the two images and then tape the print in place. Then place a register bar into the pre-punched holes of the paper. Securely tape the bar to the printing table, fold back the Mylar sheet, and print the color.

Registering Floating Shapes

Use grounded shapes, such as the flat right and bottom sides, in the same separation as floating shapes to help place the separations when printing.

Targets

Select bolder targets than those that print automatically if you are working with 230- or finer mesh. If you need to maximize the image on your print media, use another form of registration that does not use up printable room.

Photo courtesy of Jesse Hellman

Richard Hellman

Hellman, the author of this chapter, is an artist, printmaker, and educator. He has taught screenprinting at the University of Maryland, Towson University, and Maryland Institute College of Art, and he has received many awards for his screenprints, color viscosity intaglios, and digital prints. Montage Gallery in Baltimore represents his work. He can be reached at rhhprints@comcast.net and is available for teaching workshops.

Resources

Atlas Screen Supply Company
9353 Seymour Avenue
Schiller Park, IL 60176
(847) 233-0515
(800) 621-4173
www.atlasscreensupply.com
Screenprinting equipment

Autotex (TrueGrain)
www.autotype.com
Autotex textured film (F6 IJ), available in 36- x 100-inch rolls, plain or with an ink-jet coating. If you ask the company to cut it down, they will not replace the sensor strips that some wide-format printers require.

BuyLighting.com
www.buylighting.com

Casey's Page Mill
www.caseyspm.com.
Inkjet film and Translucency, a vellum-like paper made for laser printers and photocopy machines. It does not shrink and is cheaper than film but does not work in inkjet printers.

Createx
14 Airport Park Road
East Granby, CT 06026
(800) 243-2712
(800) 653-5505
www.createxcolors.com
Pure pigments and Lyntex screenprinting base

Daniel Smith, Inc.
4150 First Avenue South
P.O. Box 84268
Seattle, WA 98124
(800) 426-7923
www.danielsmith.com
Art and printmaking materials

Dick Blick Art Materials
P.O. Box 1267
Galesburg, IL 61402
(800) 447-8192
www.dickblick.com
Speedball inks, Nazdar supplies, and paper

GE Polymer Shapes
(866) 437-7427
www.gepolymershapes.com/pshapes/geps/about/locations.jsp.
L-Print-AJet .010 velvet one side (inkjet coated on polished side. GE will put sensor strips on split rolls.

Golden Artist Colors, Inc.
188 Bell Road
New Berlin, NY 13411
(607) 847-6154
(800) 959-6543
www.goldenpaints.com
Golden acrylic retarder

Graphic Chemical and Inc., Co.
728 North Yale Avenue
Villa Park, IL 60181
(800) 465-7382
www.graphicchemical.net
Lascaux tusches and printmaking supplies

Hand Print Workshop International
210 West Windsor Avenue
Alexandria, VA 22301
(703) 549-3988
www.hpwi.org
Not-for-profit printmaking studio

Lawson Screen Products
(800) 325-8317
www.lawsonsp.com
Screenprinting equipment and digital printers and supplies

Lexan, a Division of GE Plastics
One Plastics Avenue
Pittsville, MA 01201
(413) 448-5800
www.geplastics.com
Textured Lexan films, including Lexan Textured Film 8B35 112 .005 for handdrawing

Lower East Side Printshop
306 West 37th Street, 6th floor
New York, NY 10018
(212) 673-5390
www.printshop.org
Teaching facility and independent workspace for printmaking and contract printing

Nazdar
8501 Hedge Lane
Terrace Shawnee, KS 66227
(913) 422-1888
www.nazdar.com
Emulsion, stripper and screen supplies

New York Central Art Supplies
62 Third Avenue
New York, NY 10003
(212) 477-0400
Screenprinting supplies and paper; licensed dealer of T.W. Graphics water-based inks

Pearl Paint
308 Canal Street
New York, NY 10013
www.pearlpaint.com
Screenprinting supplies and paper

Renaissance Graphic Arts, Inc.
69 Steamwhistle Drive
Ivyland, PA 28974
(888) 833-3398
www.printmaking-materials.com
Createx inks, Speedball products, and other printmaking supplies

Speedball Art Products
2226 Speedball Road
Statesville, North Carolina 28677
(800) 898-7224
www.speedballart.com
Water-based poster and fabric screenprinting inks, drawing fluid and screen filler

Square Dot
www.squaredot.com
Color separation software, printing media, and refurbished Epson 3000 printers

Standard Screen Supply Corporation
121 Varick Street
New York, NY 10013
(800) 221-2697
www.standardscreen.com
Water-based inks and screenmaking facilities

ST Media Group
www.stmediagroup.com
Screenprinting books

Takach Press
www.takachpress.com
Litho presses and supplies, register pins and punches, Artex Textured Drawing Film, and photo-printmaking and screenprinting supplies and equipment

T.W. Graphics
7220 East Slauson Ave.
City of Commerce, CA 90040
www.twgraphics.com
Water-based inks and screenprinting materials and equipment

Tekra Corporation
3187 Eagle Way
Chicago, IL 60678
16700 W. Lincoln Avenue
New Berlin, WI 53151
(262) 784-5533
(800) 448-3572
(888) 550-6164
www.tekra.com
Makrofol textured acetate

Ulano Corporation
255 Butler Street
Brooklyn, NY 11217
(718) 622-5200
(800) 221-0616
www.ulano.com
Rubylith and Amberlith films and photo emulsion

US Screen
www.usscreen.com
FastPositive clear inkjet film in sheets and rolls, modified Epson printers, Postscript RIPs, FastScreens color separation plug-in, and training videos

Victory Factory
184-10 Jamaica Avenue
Hollis, NY 11423
(800) 255-5335
www.victoryfactory.com
Screens, squeegees, and other screenprinting supplies, Chromaline AccuMark inkjet film, exposure calculator, tools, and chemicals

Wacom
www.wacom.com
Intuos3 Digital Drawing Tablet

Xanté
(800) 926-8839
www.xante.com
ScreenWriter 4 Laser Printer for film positives and other graphics items

Index

Download Forms on Nolo.com

You can download the forms in this book at:

 www.nolo.com/back-of-book/LBEV.html

We'll also post updates whenever there's an important change to the law affecting this book—as well as articles and other related materials.

More Resources
from Nolo.com

 ## Legal Forms, Books, & Software

Hundreds of do-it-yourself products—all written in plain English, approved, and updated by our in-house legal editors.

 ## Legal Articles

Get informed with thousands of free articles on everyday legal topics. Our articles are accurate, up to date, and reader friendly.

 ## Find a Lawyer

Want to talk to a lawyer? Use Nolo to find a lawyer who can help you with your case.

18th Edition

The California Landlord's Law Book:

Evictions

Attorney Nils Rosenquest

EIGHTEENTH EDITION MAY 2019

Editor JANET PORTMAN

Cover Design SUSAN PUTNEY

Proofreading SUSAN CARLSON GREENE

Index VICTORIA BAKER

Printing BANG PRINTING

ISSN: 2163-0291 (print)

ISSN: 2326-0173 (online)

ISBN: 978-1-4133-2619-2 (pbk)

ISBN: 978-1-4133-2620-8 (ebook)

This book covers only United States law, unless it specifically states otherwise.

Please note

We believe accurate, plain-English legal information should help you solve many of your own legal problems. But this text is not a substitute for personalized advice from a knowledgeable lawyer. If you want the help of a trained professional—and we'll always point out situations in which we think that's a good idea—consult an attorney licensed to practice in your state.